Draw Shojo Girls
& Bishie Boys

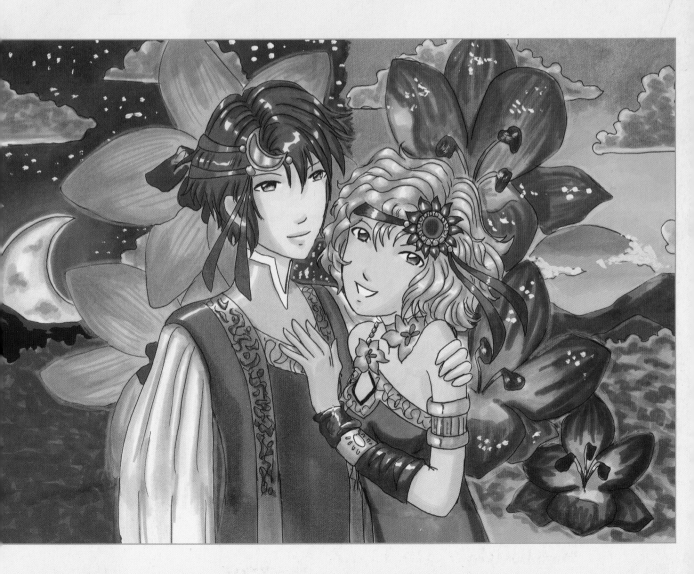

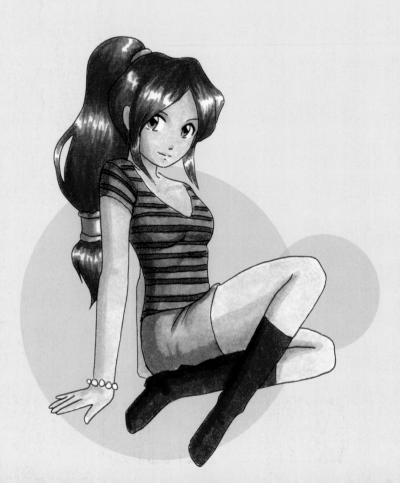

First published in Great Britain 2010 by Search Press Limited,
Wellwood, North Farm Road, Tunbridge Wells, Kent TN2 3DR

Original edition ©: 2008
World rights reserved by Christophorus Verlag GmbH, Freiburg, Germany
Original German title: Semisow, Inga: Shojo & Bishie – Manga richtig zeichnen

English translation by Cicero Translations

English text copyright © Search Press Limited 2010

English edition edited and typeset by
GreenGate Publishing Services

ISBN: 978-1-84448-529-1

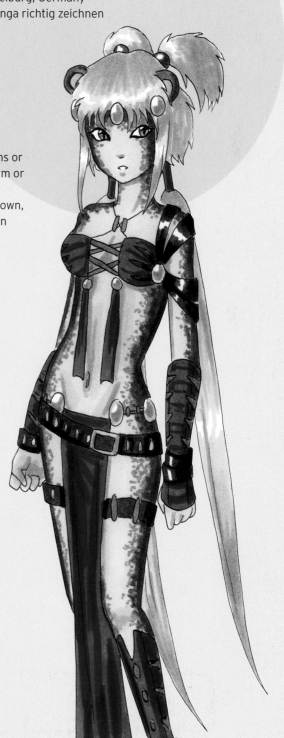

Inga Semisow

Draw Shojo Girls & Bishie Boys

SEARCH PRESS

Contents

Pretty girls and young heroes

Manga comics and films are very popular and more and more of them involve stories about shojos and bishies. But what do these words actually mean?

The Japanese word 'shojo' literally means 'girl', and in manga it is used to describe girls in general, with the focus on love, friendship and adventure. Popular figures are romantic, playful girls, such as elves, fairies and mermaids. And as exciting stories almost always involve young men, 'bishie' (from bishounen or bishonen = attractive young man) is also a popular subject in manga art. This book will teach you everything you need to know about these delightful characters and how you can learn to draw them for yourself.

I explain how to draw shojos and bishies with the help of numerous step-by-step pictures. You will learn how to start by sketching out your idea for a figure on to a piece of paper with a pencil or even a ballpoint pen. Once you are happy with this sketched design, you can transfer the outline on to tracing paper using a fineliner pen. You can then add colour: base coat, shading and perhaps some of the detail.

Perfect! Or perhaps it did not work out quite as you expected? No problem, this is just the book to help you become an expert in drawing and painting shojos, bishies and their friends.

Inga Semisow is a qualified graphic designer and illustrator. She has been drawing manga figures since the age of twelve. She has filled both children and young adults with enthusiasm for the fantasy world of Japanese manga figures through her many courses and demonstrations.

Chapter 1

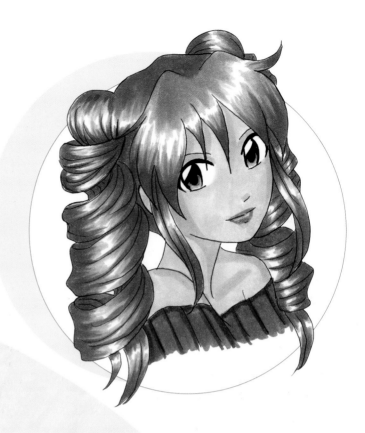

Types of materials
used for drawing and painting

Two groups of materials are indispensable for drawing manga figures: the right type of painting media and the appropriate base for the painting. The best results are achieved when both are selected correctly and complement each other. Examples of painting media are: coloured pencils and watercolour pens and paints, gouache, acrylic paints, Indian inks and of course fineliner pens and marker pens, often referred to as felt-tip pens.

Amongst others, the German company edding supplies a wide range of felt-tip pens (e.g. the edding brushpen 1340 in twelve colours). Faber-Castell has a series of colour markers for children and young people, as well as a superior series of Indian ink drawing pens called PITT® Artist Pens.

The composition of the various pens and paints differs and, therefore, what you can do with them.

Fineliner pens and marker pens have been used exclusively to draw and colour the exercises and pictures in this book (apart from the sketching out). Materials from Copic® are my favourite, with a logically organised, compatible system. They are one of the cleanest ways of working with liquid colours. The colouring medium in all the marker pens in the range is a quick-drying alcohol ink. It is an extremely fluid colour that can be used to create very attractive fade-outs and sharp transitions.

Marker pens

The range of Copic® marker pens is designed to meet different demands (and pockets). For beginners, the Ciao marker pen is the most affordable. It has the same ink as the Sketch and Copic® marker pens and is refillable with various ink. With 144 colours and a non-interchangeable, universal medium broad nib on one end and the fine super brush nib on the other end, the pen will last a long time, meeting all your needs as a beginner and beyond.

The super brush nib is best for illustrations and for colouring details. The longer version is fairly flexible, which means that you can also make really thick lines by holding it at an angle. Larger areas can be filled in using the angled, wide nib.

I recommend that you buy sets of 12, 36 or 72 colours, as this works out cheaper. You can even buy all the skin tones together in a set of 12 shades. It is more expensive to buy individual colours with any brand of marker pen.

The caps of the marker pen have the original colour and the Copic® colour number written on the side. This way, you can find the colour you want quite quickly when working, especially when you have a lot of similar shades.

However, before you spend a great deal of money on a large collection of marker pens, check out whether this type of drawing suits you.

Fineliner pens

These pens with black, permanent Indian ink are called Multiliners by Copic®. You can use them to produce the sharp outline of your figures (inking) before you colour them. Multiliners are made to co-ordinate with the Copic® marker pen system, which means that the outlines made with these fineliners will stay in place when filled in and will not run.

Fineliner pens are available in eight thicknesses (referring to the thickness of the nib) from 0.05mm to soft broad. Soft broad has a brush nib and is very practical. You can use it to work on very fine areas, when, for example, you want to put in the eyelashes and the shading around the eyes. The 0.05mm thickness is recommended for hatching, as you can see in the picture on page 16, and for black and white drawings in general.

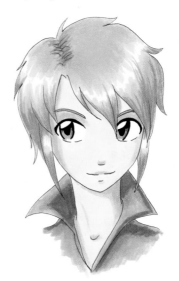

Tip

If you suffer from allergies, you may react to the fumes and smell of the ink of marker pens. If so, you will have to work with coloured pencils and watercolour paints instead.

The base

It is possible to draw and paint on almost any type of paper. But to achieve good results, the paint media - i.e. pencils, marker pens and watercolour paints - should be co-ordinated with the most suitable base.

With watercolours, for example, you need to use thicker paper, preferably a special watercolour paper, as sometimes you will be painting with a lot of water. This applies to other paints that are very fluid too, since normal paper will very quickly buckle when water is applied.

The same applies to working with Copic® marker pens, although these dry out much more quickly due to their alcohol content. Marker pen paper or layout paper is therefore ideal. It is thinner than normal paper (commercially, usually a 75g paper), semi-transparent and pervious to light. The Indian ink in fineliner pens does not run and the colour of the marker pen does not come through. The ink is soaked up, as with normal paper, but is then held there, staying intense and shiny, as the reverse of the paper is coated. On normal paper the ink appears dull and greyish. Blocks are available in A4 and A3 sizes.

Manga must-haves

Some materials that you definitely need if you are going to do a lot of drawing, you almost certainly already have at home. These are pencils for sketching out, a pencil sharpener, eraser and a ruler - and perhaps some brushes of varying thicknesses and tips, should you want to work with watercolour paints.

An artist's mannequin (available from craft shops and artists' suppliers) can help you to accurately draw figures in different poses and moving in different ways. You can use it to familiarise yourself with proportions, especially when viewed from different perspectives, and you can then transfer them correctly to your figures.

A piece of equipment that you might want to buy (but which is not obligatory) is a light table. It is good for seeing where and how fine lines run in sketches that can no longer be seen very clearly when transferring your sketch to tracing paper (see page 12, 'Inking'). All these fine lines become visible only when a light is shone through them.

Another tip is to set up a portfolio where you can store all your sketches and finished pictures. That way, you have everything together and if you arrange it in chronological order, you can see what progress you have made. You can then go back to older sketches and revise them.

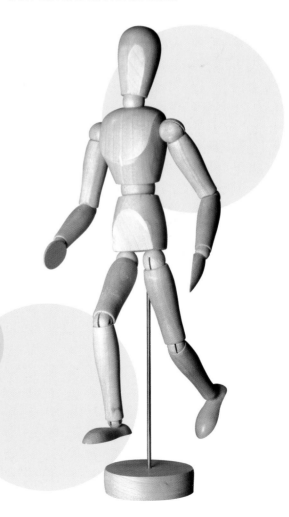

Chapter 2

Drawing techniques
a short introduction before you start

Most of the processes and techniques used for drawing and painting manga are more or less the same as those used for general painting and drawing. However, there are a few differences that characterise a manga picture. These include the choice of colour (which does not need to be realistic) and the pronounced inked outline.

Sketching out and inking

Sketching out

Normally, you would start sketching out with a pencil (or with a ballpoint pen), i.e. in black and white. If you already have some experience of manga drawing, you could also use a fineliner pen or a Copic® marker pen. Virtually all the sketches in this book are drawn with a pencil.

I always work with fine, light strokes, which can also be easily erased. You need to be able to do this if the inking lines are drawn directly on to the sketch.

For black and white manga (see page 16, 'Black and white drawing'), these lines are the final part of the picture. In coloured manga, they are the last step before the picture is given a base coat and then painted with colour.

If the initial sketch is to be transferred to transparent marker or layout paper, fix both sheets with transparent adhesive tape, so that they will not slip when transferring. The advantage of transferring is that you still have the sketch and it can always be used again as a template.

The inking lines must be sharply drawn and in such a way that all the lines are connected to one another. Usually, inking is done with a fineliner. With a paper size of up to A4, a fineliner nib of 0.3mm up to a maximum of 0.5mm is recommended. For thicker lines, with A3 paper for example, use nibs from 0.5mm to 0.7mm.

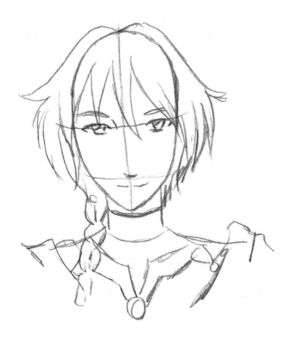

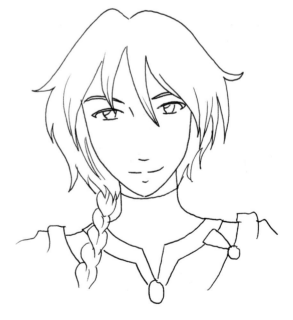

Inking

Inking refers to the sharp outlines that you either draw directly on to the paper on your sketch or on to transparent marker or layout paper (see page 10, 'The base').

Using colour

Colour symbolism and colour range

The three primary colours (yellow, red and blue) make our world really vivid, whereas white and black are monochrome. Colours can create a happy atmosphere or a sad one. This depends upon the way they are used. Some colours symbolise particular qualities, e.g. red stands for love, green for envy and violet for jealousy.

In coloured manga pictures, hair colour plays an important role. It is possible to give a figure character through this external characteristic alone:

- Red stands for temperamental, hot-blooded and quick-tempered.

- Yellow (blonde)/pink stands for innocence, naivety and being well-behaved and playful.

- Turquoise/green stands for noble, fantastical and enigmatic.

- Violet/blue stands for quiet, reticent and mysterious.

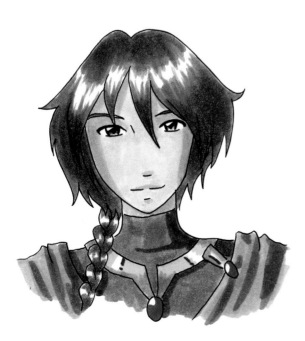

The same applies to the clothes of your figures. Usually the evil figures are dressed in black, dark red or violet and the good ones in white or pastel shades.

On the general colour spectrum, the colours between yellow and red, in the orange range, are considered to be warm colours; those between red and blue are in the transitional range between warm and cool; and the colours between blue and yellow with green tones are considered to be cool colours.

Which colours go together well? The answer is the complementary colours – those that are opposite one another on the colour wheel, but that complement each other and, in doing so, emphasise their brightness. Examples are orange and blue, yellow and violet, and red and green. Cool shades contain more grey, which is made from black and white.

Blue/orange, a typical cool/warm contrast.

However, as you do not want to create pictures in just two colours, it is advisable either to paint them in a cool/warm contrast or simply to use colours that provide an accent, such as a red precious stone against green or blue.

Colour fade-outs

Colour fade-outs can brighten or darken the atmosphere of a picture. A dark to light fade-out achieves a positive, happy atmosphere. If the fade-out is reversed, the atmosphere is usually darkened. You will need some patience and practice in order to paint smooth fade-outs and transitions:

B05

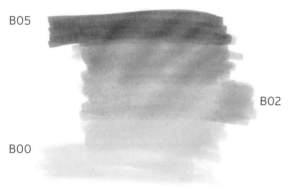

B02

B00

- First apply a base coat for the whole area of the fade-out in the lightest shade (here B00 Frost Blue) and then go straight over it again with the same shade. Avoid painting over the very start of the lightest area a second time.

- Move straight on to the next shade (here B02 Robin's Egg Blue) and paint over the rest of the fade-out to make it darker. When painting for the second time with B02, leave out a strip of B02, as before.

- Finish off the fade-out with a strip of the darkest shade (here B05 Process Blue).

The colours referred to above are from the Copic® range, though other brands usually offer a similar range of colours that are equally suitable.

Shade and light reflections

Shade and light reflections add life to figures and objects.

To get the shade just right, you must first decide from which direction the light is going to fall. If the shade appears where the light falls, it is wrong. These simple shapes show correct shading.

Cylinder: light from the front

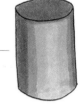

Cube: light from below, from the front

Cone: light from the left

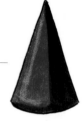

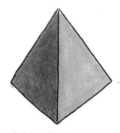

Pyramid: light from the right

Light reflections may be given different names, but they all use the same drawing techniques.

In this chapter we cover reflected light in hair. Other forms are light point, when a single ray of light meets a non-reflective surface, and light reflection, which is usually used to suggest the reflection of light in the eyeball. Examples of these are given on page 25 in the 'Shapes of eyes' section. The artistic reproduction is always determined by the angle at which the light falls.

Shading skin

In some of the examples in this book, the original Copic® marker pen colour descriptions are used, as shown here.

When you are shading skin, work with three Copic® shades – E00, YR00 and E11, for example. Apply a base coat of E00 to the skin and then using a pencil, place a little arrow at the point from where you want the light to fall, by way of an aid. Paint the sides that are turned away from the light first with YR00 and then with E11. With E11, the stroke should not be too thick, or the shade will be very harsh.

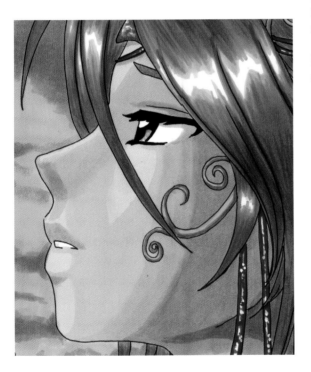

Shading and reflected lights in the hair

Hair is made up of many separate strands and these, in turn, are made from individual hairs. Together they form an intricate structure, but one that can be easily drawn. As always, apply a base coat using the lightest shade.

The individual strands of hair are always painted flowing away from the tip in individual strokes in the direction of the area of reflected light. When hair is well depicted, the shine is in the foreground.

The places that shine when struck directly by the light are simply left white. To do this, you break the brush stroke by raising the brush to give fine hair tips. The white of the paper then forms the shine. You will not need to use Tipp-Ex® or any other white correction fluid.

Continue painting the strands, starting from the roots of the hair (rather than away from the reflected light area) and paint in the direction of the reflected light, ending the paint stroke again by raising the brush.

Paint the shading with the next darkest shade in the same way.

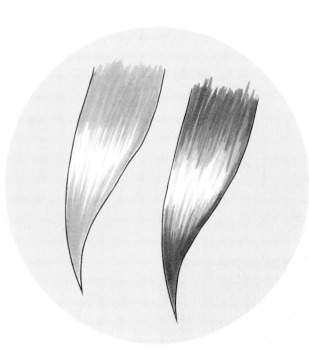

Black and white drawing

Originally, manga comics were almost always drawn in black and white. It is certainly true that great paint effects can be achieved by using just black and white, as is often seen with comic strips.

You can achieve these effects just by shading. This gives pictures a lot of depth and movement, making them appear livelier. Each of the following three drawing materials gives the picture a different appearance and changes its character.

Using a pencil

Drawings using a pencil appear light and slightly blurred, which makes them very soft overall, especially if you lightly hatch over them with a softer pencil.

By using different types of pencil or by pressing more firmly with a B pencil, you can achieve different levels of shading.

Using a fineliner pen

Drawings done using a fineliner pen look fairly stark compared with a pencil drawing. The effect is typically suitable for manga drawings. Remember, though, that you cannot erase the lines or change the drawing.

When shading, very thin fineliner pens are recommended. In this example, the shading has been done with a Copic® 0.05mm. These hard lines are perfect for very dynamic motifs.

Using a marker pen

You can add a lot of depth to the picture using the Copic® Ciao marker pen, especially in the grey shades C1, C3, C5 and C7. Even without using colour, these pictures appear full of life. The drawing is harmonious and, despite the sense of movement, has a very calming effect.

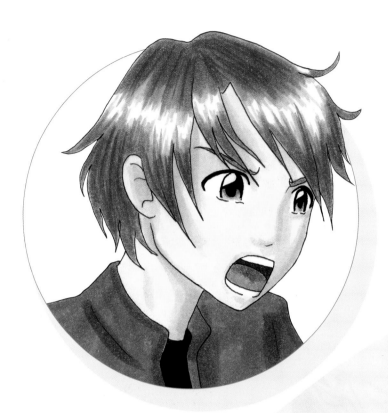

Chapter 3

The head
typical manga features

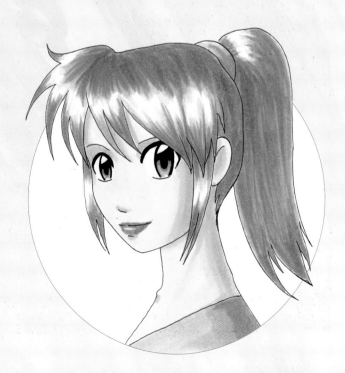

A girl's head from the front

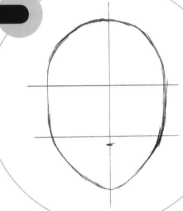

When starting out, it is easiest to draw a figure from the front view or in profile (see page 22). For the face, using a pencil, first draw an oval that tapers to more of a point at the chin. Mark the centre of the face with a vertical line. The upper horizontal guideline shows where the high forehead begins. The nose sits on the lower line that begins just above the jaw bone. From this line, the oval of the face tapers to more of a point.

Step 2

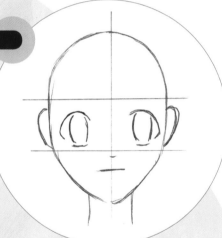

In manga pictures, the eyes play a dominant role. They are characteristic of this type of art. Usually, the width of the eyes and eyebrows in manga figures is around a fifth of the width of the face. However, the eyes of a shojo are bigger. In this case, one eye will fit only four times into the width of the face. The ears are at the same height as the eyes between the two guidelines.

Step 3

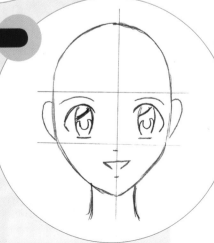

To make the eyes look really lively, add pupils and light reflections. The light reflections are drawn thinner for girls than for boys. The shape of the eyebrows also adds to the liveliness and establishes the characters and their moods.

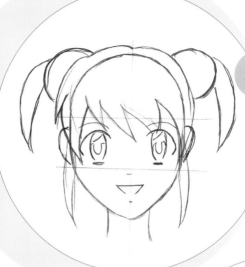

Step 4

As the forehead of a shojo girl is very high, a full head of hair can be drawn over it. Outrageous hairstyles are very popular. Their fantastical shapes often go way beyond realistic hairstyles.

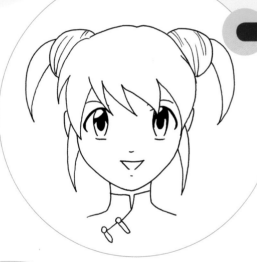

Step 5

To achieve sharp outlines, draw over the pencil lines with a fineliner pen. Erase any pencil lines that are still visible.

The sharpest method is described on page 12, under 'Inking', where you transfer the pencil drawing to tracing paper. When this is done there are also no more guidelines.

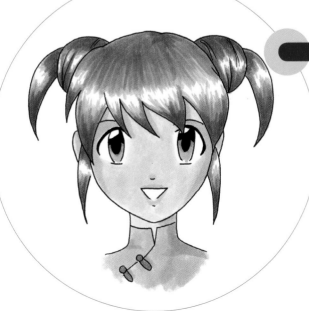

Step 6

The drawing is now painted in your colours (see page 13, 'Using colour', onwards).

Tip

The reflected light in the hair must sweep upwards at the sides. This will emphasise the curve of the head.

A boy's head from the front

Step 1

With boys too the head forms an oval from the front, tapering to a point at the chin. The rest of the details are the same as for the girl's head on page 18.

Step 2

This applies to the eyes too. They are also so big here that they will fit only four times into the width of the face.

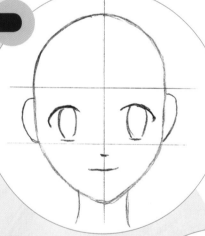

Step 3

Give the eyes their liveliness with pupils and light reflections (see page 25), establishing the character and mood of your figure. The shape of the mouth also has an influence. Here, just one small stroke forms the mouth, with two shorter strokes above and below to indicate a dimple in the chin and the nose. The boy's eyebrows are generally a little wider than the girl's. The ears are at the same height as the eyes.

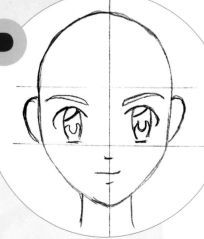

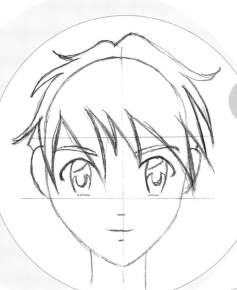

Step 4

The shape of the hairstyle is sketched out only roughly at first. In this example, it is very short at the back and around the ears. It is somewhat longer over the forehead and face, with the fringe separated into strands.

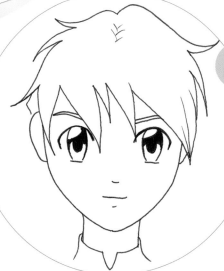

Step 5

Finish off the inking as described on page 12. Shojo figures show young people. This is why you generally do not find any expression lines on the face. The expression on the face is principally determined by the shape of the eyes and the mouth.

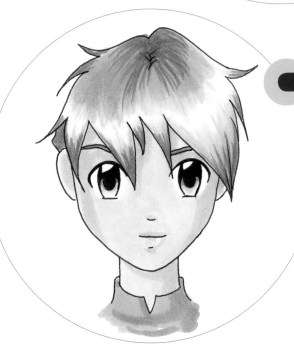

Step 6

The picture is given its finishing touches by adding colour (see page 13, 'Using colour', onwards). The result is a picture of a boy without much sense of inner movement, who looks virtually neutral in mood.

Tip

The head of a young boy in profile or semi-profile can be drawn in a similar way to the bishie on pages 58-59.

A girl's head in profile

Depicting a head in profile is very easy, just like the view from the front. Draw the shapes for the nose and chin by making notches. The positions of the individual parts of the head and face are governed by strict anatomical rules, though you will always find exceptions.

If you look at a head the same size as your own face, the ears and nose sit at around the level of the middle of the head. The eyes lie at the level of the notch between the forehead and the start of the nose.

Step 1

The basic shape of the head in profile is a circle.

Step 2

Roughly draw in the details in the circle: the notch for the nose, the position of the eyes, mouth and ears. Roughly sketch the hairstyle too.

Step 3

Complete the details for your figure, such as working on the eyes, the initial stages of the clothing and the final shape of the hairstyle. Finish it all off by inking.

Step 4

The subtle colour scheme adds more life to the face.

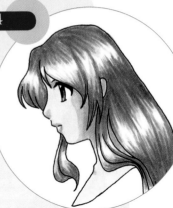

Tip

The ear shows how young your figure is. The closer it lies to the profile of the face, the younger the figure you have drawn.

A girl's head in semi-profile

A face looks livelier in semi-profile than from the front, but it requires particular attention before drawing. The back part, which is our left side of the face here, curves inwards slightly from the eyebrow. The eye on this side is drawn a little smaller. This is due to perspective, making this part of the face appear to be further away.

The centre of the face has shifted too, i.e. the altered perspective means that the surface area of the face appears reduced to the observer and cannot be seen in full any more. Consequently, the positions of the nose and mouth also shift down a little and to the left in semi-profile. To make it easier for you to know where the eyes, nose and mouth should be, divide the face as in the sketch using slightly curved guidelines.

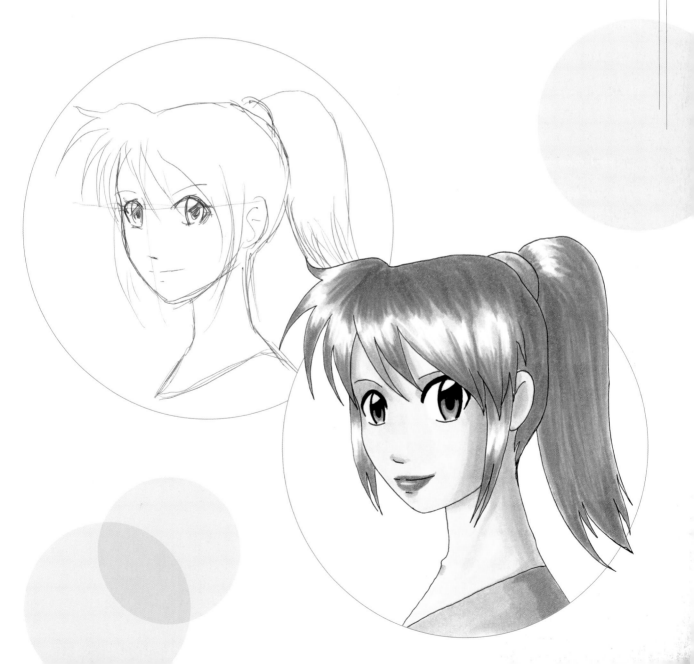

Shapes of eyes
characteristic features of manga figures

The eyes are the most distinctive characteristic feature in manga drawings. The big eyes of these manga figures are very expressive and the various eye shapes indicate their mood or character. You can also use them to show whether your figure is supposed to be good or evil.

It is quite normal for the shape of the open eye to be drawn in an exaggerated, or even distorted, manner.

The eyes can take on all kinds of shapes. Very often, you'll find eyes that are drawn almost rectangular, often elongated or even with a square iris.

The expression of the eyes comes from the particular positions of the white in the eyeball, usually without using any colour.

The open eye

Step 1

First, draw the rough shape of the eye, using double lines for the upper lid and a single stroke for the lower lid. Here, the iris is a slightly curved rectangle, stood on its end.

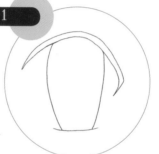

Step 2

Draw in the outline of the light reflection, the contours for the pupil and the upper shadow that falls on to the eye. The light reflection is also included, coming from the side from which the light falls (from the left as you look at it). It forms the shine in the eye.

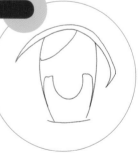

Step 3

Colour scheme: the pupil here is black, as is the shadow in the upper part of the eye. The light reflection area remains unpainted and white here. The lower part of the iris is in Water Blue with fine, darker strokes.

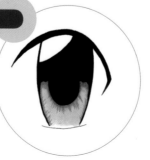

Tip

When colouring the eyes, you can give your imagination free rein, as the whole spectrum of colours can be used in manga drawings.

The closed eye

There are various ways of indicating closed eyes. In the following three examples, the upper, thinner stroke represents the eyebrow and the lower, thicker stroke is the end of the eyelid with the eyelashes.

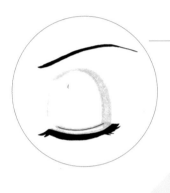

Eye with shading to indicate the eyeball beneath the shut eyelid. Leave the centre of the eyelid light; only the end above the eyelashes is a bit darker.

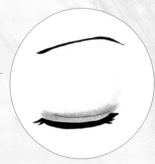

Eye with just the fold of the eyelid, with continuous shading. The eyelid is indicated using just a single stroke.

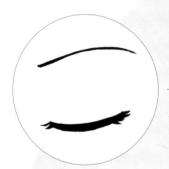

Eye without visible eyeball and eyelid. There is no indication of the eyelid at all. You only know from the eyelashes that the eye is shut.

Eyes in different colours and with reflections of light

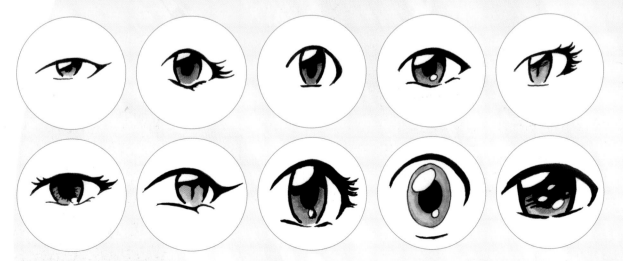

Facial expression indicating moods

It is not only the eyes that show your figure's feelings and mood; the shape of the mouth is another indicator. Other than this, the faces of shojo figures are represented very simply. There are no unnecessary strokes (that might indicate frowns for concern, worry or fear), as these additions only make your youthful figures appear older. Line- or wrinkle-free faces give the figures a sweet and innocent look. However, if your figure needs to show great feeling, which is very often the case for shojo figures, you should make the shapes of the eyes and mouth as expressive as you can.

The strength of the facial expression can be emphasised further and perfected by using matching body language (see page 40, 'Gestures'). For example, making the hand into a fist indicates anger; both hands raised triumphantly in the air indicates happiness.

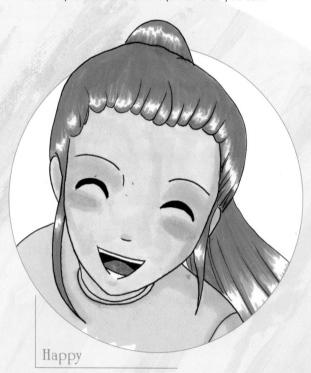

Happy

CHARACTERISTICS: The head is tilted to the side and gives the impression of movement (perhaps the girl is shaking with laughter!).

Her long hair is also moving sideways.

As her eyes are shut from laughing so hard, the distance between the eyelid and the eyebrows has increased.

The mouth is wide open in laughter.

Shocked

CHARACTERISTICS: The head is tilted back slightly.

The eyeballs come forward and are enlarged, as the pupils are very small and circular in the oval irises that are drawn looking upwards.

The mouth is slightly open, as if questioning.

The gesticulation – hand to cheek – emphasises the facial expression of horror, 'Oh no, I don't believe it!'

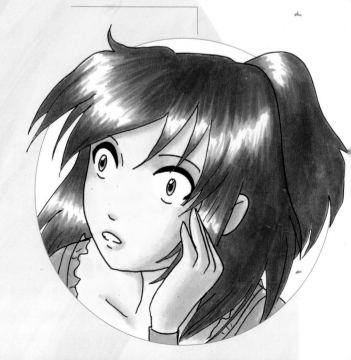

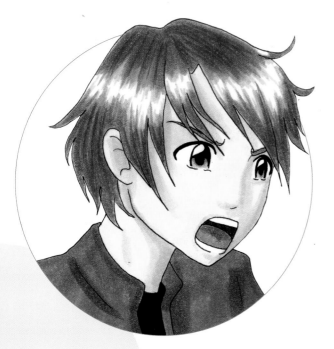

Angry

CHARACTERISTIC: The head in semi-profile is aggressively thrust forward. The long neck straining forwards emphasises the aggressive stance.

The eyes are quite large, but narrowed and are more slanted.

The mouth is wide open and you can see right inside due to the perspective (slightly from above). You can virtually hear him shouting.

In love

CHARACTERISTICS: A slightly tilted head with softly falling hair: a pose that appears to be open and honest. Who is this girl with big eyes looking at? What is she thinking about?

The mouth is slightly open and like the eyes, it is drawn fairly naturally.

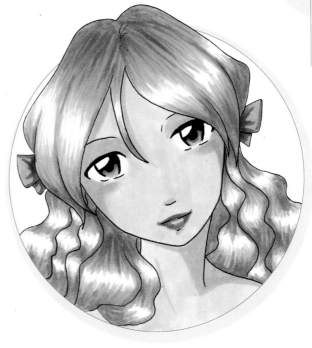

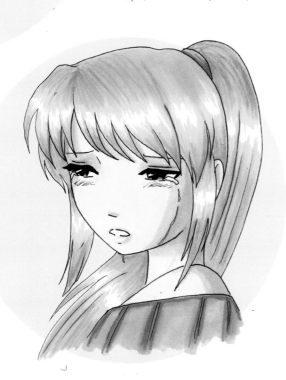

Sad

CHARACTERISTICS: The head held upright is drawn in semi-profile.

The virtually closed eyes (barely open slits) gaze into space.

Finely drawn lines under both eyes indicate the swollen eyelids and there is also a tear at the edge of each eye. These details are drawn with the thinnest fineliner pen.

Cool hairstyles
a characteristic of manga figures

As well as the shape of the eyes, the type of hairstyle plays a great role in manga figures. Hairstyles are particularly important for shojo and bishie figures, where the hair is often the most striking characteristic, due to its abundance and luxuriously crafted shapes. This is, of course, even more evident in girls than in boys. Certain shapes of hairstyle occur again and again in manga.

Soft and wavy

The hairstyle for good, attractive, intellectual boys.

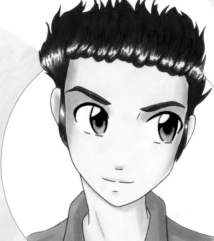

Crew cut

The hairstyle for sporty types, skaters, bikers and breakdancers.

Smooth, long and tied back

The hairstyle for dreamy boys who want to be a bit different.

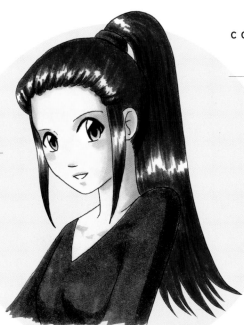

Ponytail

A girl from the 1960s. This hairstyle is timeless and still often seen today.

Single plait

Cheeky turned-up nose, wide-eyed and self-confident. In the past, only country girls wore a plait like this, whereas nowadays you will see this hairstyle as often in a fashion boutique as on a university campus.

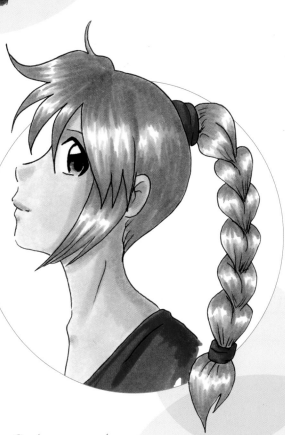

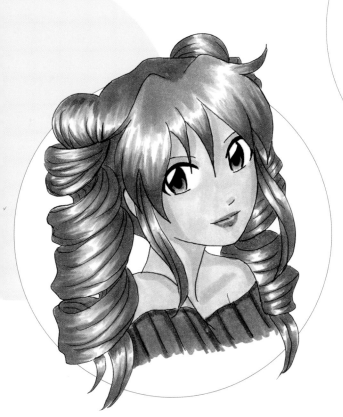

Corkscrew curls

Ornate double curls and a soulful look go well together. An unusual hairstyle that would look good for a gala evening or a spectacular ball.

Chapter 4

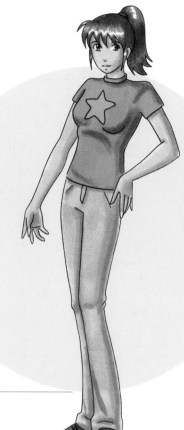

The body
the basic shape for your figures

The proportions of the body adhere to specific rules. The painter Albrecht Dürer, who lived from 1471 to 1528, considered the proportional height of a grown man to be eight head lengths. For children, the proportions differ according to age. The same applies to women.

If you look closely at a person, you will easily see that the other parts of the body, particularly the arm and leg lengths, are in a specific ratio in relation to the whole height of the body. However, there are always exceptions. Some people might have ape-like arms, because they are so long, whereas others might have short, stumpy, bandy legs.

The female body

Shojo female bodies are very delicate with fine limbs. In young girls, the hips are very narrow and the shoulders are wider than the hips, which round out more as they develop into women, as do the arms and legs. These proportions give the figures an elf-like appearance. At this age, the body is the length of six heads; as an adult it is seven heads high.

Step 1

This figure is not intended to be seen as an initial sketch, but as an example of the construction of a girl's body. First, roughly draw the pose using single strokes - similar to an artist's mannequin. You can depict simple, resting positions in this way or even dramatic movement. At the start, this relatively simple figure will be sufficient for remembering some of the proportions of a girl's body. But the correct length of the arms and legs is not always easy to work out when it comes to foreshortening (see page 44, 'Foreshortening').

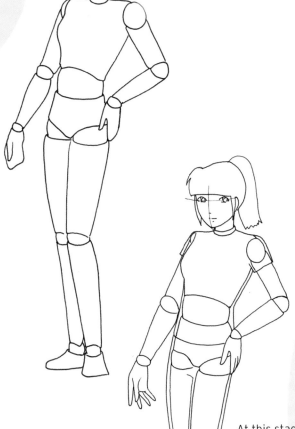

Step 2

At this stage of the drawing, place the clothes over the basic shape of your figure and draw the face and hairstyle.

Step 3

In the final stage, it looks something like this. You can then colour your drawing.

The male body

Manga male figures are fairly angular in stature. The waist is wider, so that the upper body does not taper in so much. The arms are muscular. The neck too is somewhat wider than the girl's neck. Boys are usually half a head taller, i.e. six-and-a-half heads, and as adults seven-and-a-half to eight heads high.

Their demeanour is such that manga male figures exude a certain composure and self-confidence, whereas the female figures usually appear to be playful and childlike.

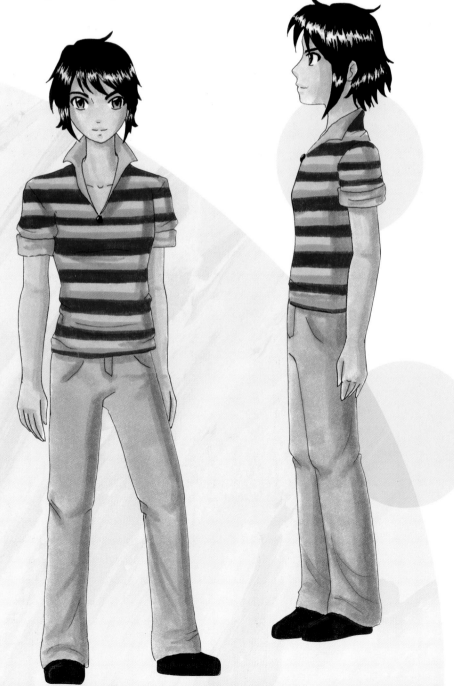

Tip

When the arm length is correct, the elbows are at waist height. The forearm with hand is almost as long as the upper arm.

Hands

Drawing hands correctly is just a matter of observation and of course practice. This applies to manga drawings too, where the hands help considerably in emphasising the body language. For instance, a fist is the expression of anger and rage.

The basic shape of the hand

With the stretched-out fingers the hand forms an oval. If you look at your hand, you will soon see that the fingers are not all equally long and that they have three joints. At the base, the joints form knuckles that play a role in the depiction of various positions and at the very least need to be suggested in your drawing. This will stop you from creating 'sausage fingers'.

The middle finger is the longest and the little finger is the shortest. The index finger and the ring finger are usually around the same length. Only the thicker thumb stands to one side (as in the diagram) and is set lower down the hand than the rest of the fingers.

Practising sketching hands

To learn to draw hands really quickly, draw your own hand in different positions. Rather than a true-to-life representation, shojo hands are simplified and are often drawn in such a way that they taper down very narrowly at the ends and therefore appear to be very delicate. Even bishie hands are very delicate: there are no warriors with bulging muscles.

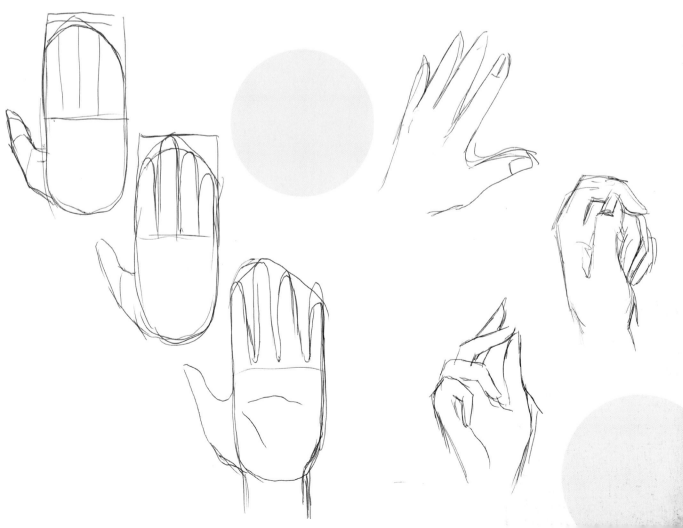

Feet

In most pictures, you will see feet in shoes or stockings or covered by clothing. Bare feet are usually seen only on fairies, elves and people on the beach. You will learn what the side view of the foot looks like fairly quickly. Views from below, above or from behind around the ankles require some practice.

Here are some examples of different views of feet that you can practise. Hands and feet have the same number of toes and fingers, but differ considerably in terms of their form. Viewed from the front, toes seem to make steps from the largest to the smallest toe. For shojo figures, you can draw the feet very daintily.

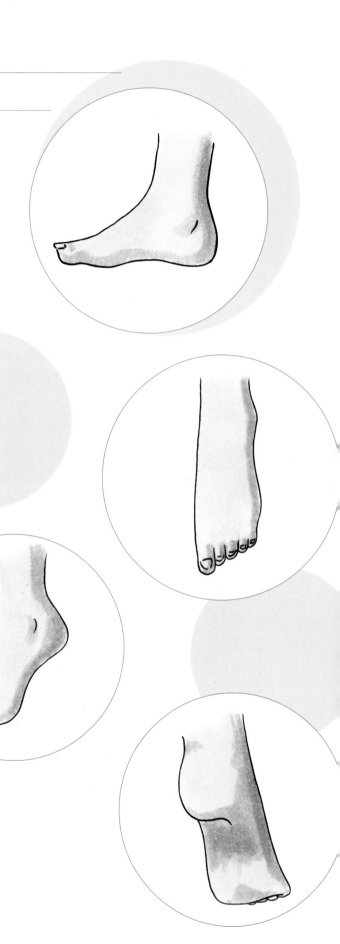

Posture and body language

Posture

Posture can make your figures interesting and bring them to life, whether stationary - sitting, lying or standing quietly - or moving - walking, running or jumping - and there are even more variations within these postures. If you take a sleeping pose for example, you can lie on your back, on your side or curled up.

Even more possibilities are available when representing sports, such as rollerblading, ice-skating, playing volleyball or light athletics. You can decide for yourself the posture that you would like your manga figures to adopt. Whatever you decide, you will need to learn to observe such poses very carefully and practise until you are able to depict more difficult postures correctly as well. The chapter on 'Foreshortening' on page 44 is a very important aid to understanding. In the following examples, you will learn about all the things you need to be aware of.

Running - the rollerblader

When depicting this rollerblader, you should look carefully at her movement. Her stance is that of energetic forward movement. This comes from the body being bent forward at the hips and from the angles of the legs and arms.

Step 1

Figures that are required to hold a particular pose in a picture should initially be roughly drawn, preferably in the form of a mannequin. This is very important for getting the representation of the joints right when sketching out, or for making a special feature of them.

Step 2

Once you have the posture of the figure, draw in the details for the face and clothes. Accessories, such as glasses, elbow-, hand- and knee-protectors, should also now be indicated but not fully worked on until the next step. The direction of the hair should also be drawn in line with the movement of the figure.

Step 3

Before painting in the colour, all the details are checked carefully (here, elbow- and hand-protectors and the neckline of the sweater) and all the lines are sharply defined using a marker pen or a fineliner pen, or transferred to tracing paper by inking. You can then begin with the colour scheme (see page 13, 'Using colour').

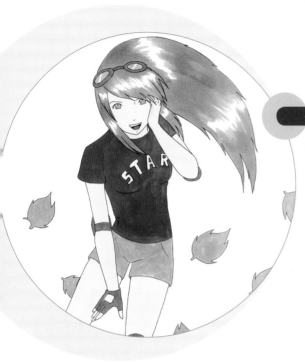

Step 4

Start with the base coat, i.e. choose the lightest shade for the surface in question.

Step 5

Your figure will start to come to life when you shade the clothing, skin and hair. For this step, use the next darkest shade. This applies to the hair too. To make the hair shine, you must allow the background to show through as white in places where the light falls.

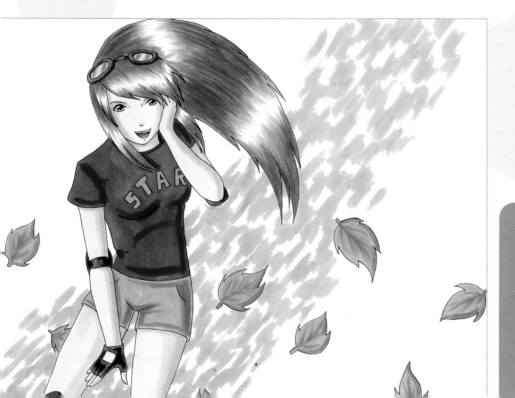

Tip

Before applying the base coat, test which colour is the lightest and which the darkest, as when you are colouring with Copic® marker pens you cannot correct your work.

Leaning – boy against a tree

The boy's casual pose is achieved through the bend of his leg and from his hands being in his trouser pockets. Additionally, his whole body is tilted backwards as he leans his shoulders against the tree. The casual pose is also emphasised by the straightness of the tree in contrast to the boy.

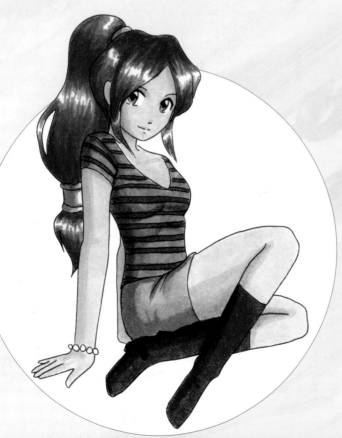

Sitting – girl in a mini-skirt

The girl in a mini-skirt is sitting in a cheeky position. Her body and supporting arms are in parallel; her legs are crossed in a very ladylike way. When drawing the legs, you must take into consideration the necessary foreshortening. Here it is the front leg that is held at an angle to the observer.

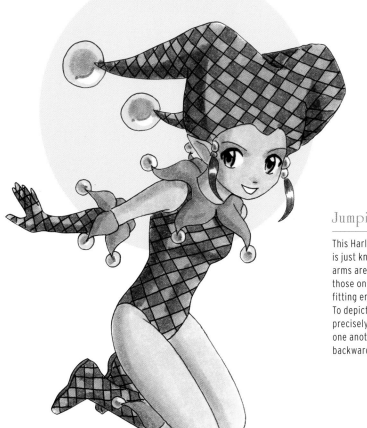

Jumping - the Harlequin elf

This Harlequin elf is jumping (in case you think that she is just kneeling). The following details prove this: the arms are flung back and the bells are flying, especially those on the hat. Had the figure been drawn within a fitting environment, there would have been no doubt. To depict a kneeling elf, the shins and body, or more precisely the body axis, must stand at right angles to one another. Otherwise the girl would fall over backwards or fall forwards.

Lying - the sleeping girl

As she is lying on her side, her head is tilted up in semi-profile. Her body is curled up and only the torso needs to be painted, i.e. the legs are only hinted at under the blanket and are not drawn fully through to the feet. A quirky feature of this sleeping posture is the hand hidden beneath the pillow.

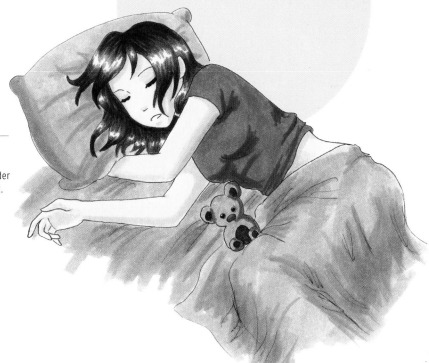

Gestures
body language

Gesture and body language complement your figures' facial expression of emotion. So this means that the whole body reflects a figure's momentary state of mind.

With shojo figures, this makes the representation very lively, especially when the whole body - particularly the head, arms and hands - reacts to an emotional situation and takes on a fitting posture. The following four examples show how this might be done in practice.

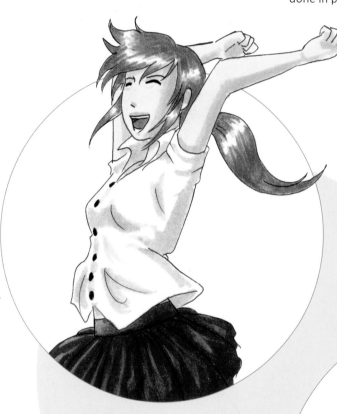

Happy

Both arms are raised to complement the facial expression in a triumphant cry ('I've won!' 'I got an A!' 'It's the holidays!'). The upper body is slightly bent backwards. The whole figure looks as if she wants to hug the entire world at that moment. You could also draw this happy girl taking part in a Mexican wave at a sports stadium.

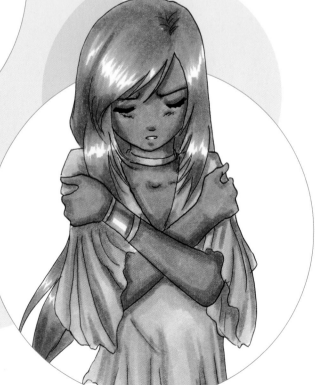

Sad

The figure is cutting herself off from the outside world. The head is tilted downwards and both arms are crossing her chest, meaning 'I want to be alone with my sadness'. The facial expression (with closed eyes) is saying the same thing.

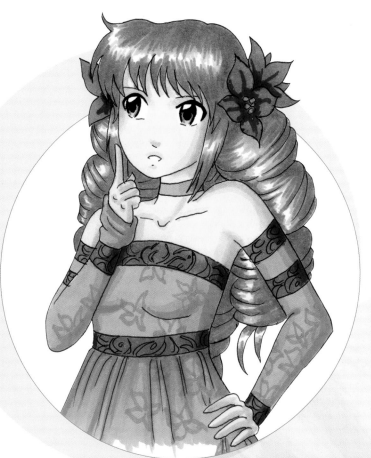

Thoughtful

Thinking means turning inwards and concentrating on something. This is shown by the upright posture with an arm supported on the hip and a raised arm with the index finger pointing towards the head. The facial expression adds to this: wide eyes gazing into the distance.

Tired out

The body is 'broken'. The upright posture has gone. The head is hanging down. Only the hands are still supporting the kneeling posture of the girl. The facial expression reflects this too: eyes and mouth are closed.

Chapter 6

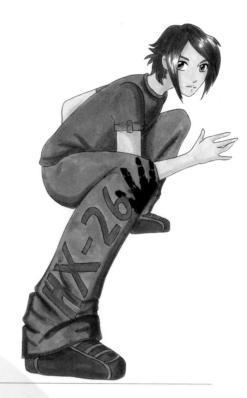

Perspective
the basics

When using perspective, three-dimensional objects (buildings, people and streets) are represented on the two-dimensional surface of your drawing paper in such a way that they are given spatial depth.

Perspective is based on the laws of geometry. You need to know a little about it, so that you can use it in your artwork to make it realistic and lively. You might already be familiar with terms such as a worm's-eye view or a bird's-eye view, or have at least heard of them.

When the perspective is not quite right, you always notice it. Human beings instinctively know if something looks right and the eye tells the brain when something is visually not quite correct. So, working with perspective is just a matter of observation; with repeated practice, you will be able to use it in your drawing.

It is not possible here to go into the theory behind perspective, which would in any case take up too much space. However, you need to be familiar with a few terms, and you will be able to understand them better with the help of pictures.

All about the vanishing point

To create perspective, you need to know the vanishing point(s). Some perspectives have one, two or even several vanishing points. The vanishing point is the place in the distance to which all the guidelines lead from the object depicted. The vanishing point is always on the horizon, which is your eye level.

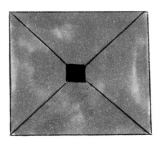

With one vanishing point

This is the construction of a perspective with one vanishing point, which is at eye level. In this example, it is in the centre of the dark square.
This example is like looking into a tunnel or an endlessly long room. The floor and ceiling demarcations here are also the straight lines that meet at one point: the vanishing point. In this example, it is as if you the viewer are standing in the picture.

Bird's-eye view

This example shows a cuboid viewed from a perspective with two vanishing points. The horizon line, or your eye level, lies above the cuboid, which is why you can look down on to its top surface. This way of viewing something, as if you are flying over it like a bird, is therefore also known as a bird's-eye view. In manga drawings this occurs, for example, when viewing a town from above, which gives the feeling of distance.

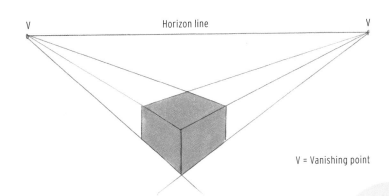

V Horizon line V

V = Vanishing point

Worm's-eye view

If, as here, you place the horizon line under the cuboid, it looks as though it has been stood on a sheet of glass and that you are looking at it from below. This, again, is a perspective with two vanishing points. It is called a worm's-eye view, because you are looking up at the cuboid from below like a worm; rather than looking at the top as in the bird's-eye view, you are looking at the underneath.

In the following examples, you will see how perspectives affect manga figures. There are some very clear effects: the nearer the body parts in the foreground are to the observer, the larger they are portrayed, and foreshortening may occur.

V = Vanishing point

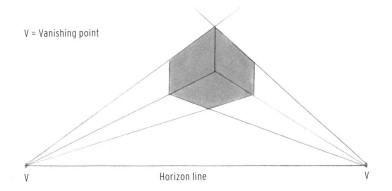

V Horizon line V

Foreshortening

This arises when the surface of an object appears to be compressed from a 90° angle to the observer and therefore less of it is seen.

This might seem complicated, but it is not. You can understand it quite easily: take, for example, a piece of A4 paper and hold it at arm's length with the lower edge at eye level. If you now tip it backwards, you will see even less of the surface of the paper. If it lies completely horizontal, you will see the bottom edge of the paper only as a strip. The same thing happens when tipping the paper forwards and when turning the sheet sideways. The same applies to three-dimensional objects.

In manga drawings, foreshortening is often used in fighting scenes or when a figure is performing magic, as with this type of representation the observer is pulled right into the event. The observer has the feeling of being in the centre of the action and of being very close to the figure.

Look carefully at the following figures from all these viewpoints.

Karate fighter

The blue-haired karate fighter is standing at eye level. The most striking point about her is the large hand in the foreground and the shortened arm. The foreshortening here is the result of her being turned sideways from a 90° angle to the observer.

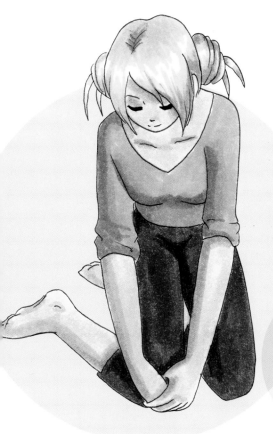

Kneeling girl

This kneeling girl has been drawn from a slightly bird's-eye view, i.e. the observer is standing a little above. The bent upper body is optically foreshortened in relation to the whole figure.

Female alien

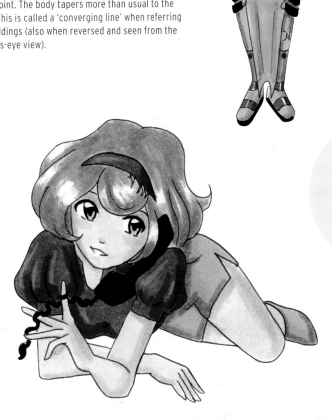

This female alien is drawn from a strong bird's-eye view perspective. The head is extremely large, with the body being just two heads high from this viewpoint. The body tapers more than usual to the feet. This is called a 'converging line' when referring to buildings (also when reversed and seen from the worm's-eye view).

Girl lying down

The girl lying down with the telephone shows a very strong foreshortening of the body. Her head, shoulders and chest are depicted the right size, as are her right arm, the left upper arm and the left leg down to the knee. The rest of the body (the calves and a foot, which are virtually hidden) cannot be seen at all. The left forearm that is playing with the telephone cord is foreshortened. Why is this? Just remember the example of the tilted sheet of paper mentioned at the start of this chapter and what happens when it is turned away from a 90° angle to the observer. You will then understand all the foreshortenings in the depiction of this figure.

Cat girl

The cat girl is drawn from the worm's-eye view with enlarged legs closest to the observer. This makes the upper body not only narrower, but also foreshortened due to the fact that it is leaning backwards. This is exactly the same phenomenon as when a sheet of paper is tilted backwards.

Breakdancer

The breakdancer is also portrayed with an extremely enlarged leg. Although the figure is at eye level, this distortion occurs due to the proximity of the leg to the observer. The rest of the body is moving away from the observer into the background and is significantly foreshortened in relation to the leg.

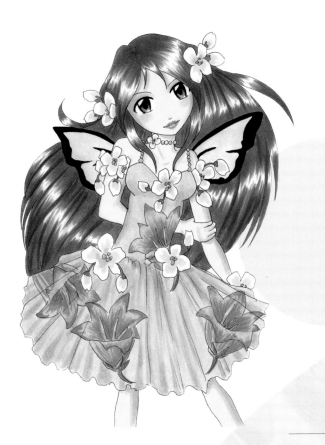

Chapter 7

The finishing touches
adding atmosphere to your picture

When clothing your figures, you can let your imagination run riot. Depending on where and in what era you locate your figures, you can use chic, fashionable clothing that you are familiar with or you can select clothes from a different time period.

In Renaissance or Baroque times, clothing was very ostentatious; even the outer layers of men's garments were flamboyant. The women had their hair piled high or had full (or false) curls that were decorated with lots of tiny objects like leaves and flowers or fruits and feathers. They also wore elaborate jewellery made from pearls and precious stones. The men's outfits were decorated with gold. Beneath their fine jackets, they wore frilly shirts.

You can be your own fashion designer with fantasy, fairytale-like or futuristic clothes, as well as dreaming up something completely new. You can use anything that you can think of in terms of materials, e.g. beads, feathers, chains or small figures. In this respect, hippies and punks have always been very imaginative.

Clothing

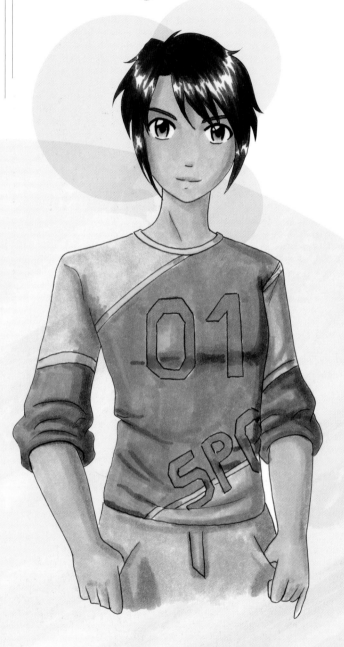

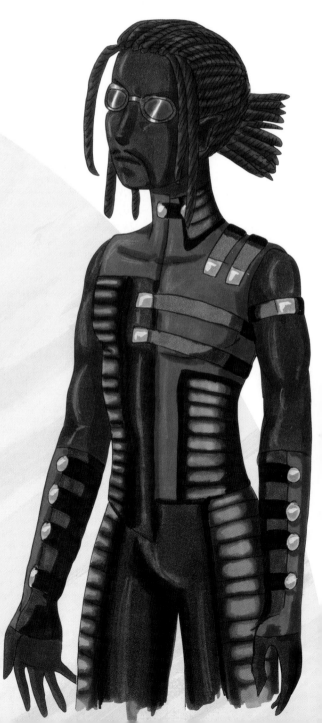

Afro look of a science-fiction figure

Dreadlocks, reflective sunglasses and engineered pieces of clothing that emphasise the body – he has the appearance of a figure that might have come out of science fiction.

The nice boy from next door

He still goes to school or is already training as an office worker. He wears his trendy sweatshirt at every opportunity, no matter where he is, whether meeting up with friends on the playing field or at an open-air concert. Nowadays, casual wear is usually simple in style, but brightly coloured and often with printed or sewn-on pictures and lettering.

Costume from the eighteenth century

A well-to-do bishie is dressed in this elegant coat that is close cut and highly tailored. His wealth is evident from the rings on his hand, his coat encrusted with jewels and his lavish, frilled shirt. Yet his appearance is unconventional, as he would normally have been wearing a wig in that era.

Rococo costume

In the eighteenth century, the fashions in the noble courts and in the salons of the well-to-do bourgeoisie were extremely elaborate. In this costume, the hoop skirt is the most striking aspect; a coat-like overdress is worn on top of it, divided into sections tied back with flowers. A bodice, like the sleeves of the dress, is edged with ruffles. The curly wig and fine jewellery complete the picture of a lady who looks like a fairytale princess.

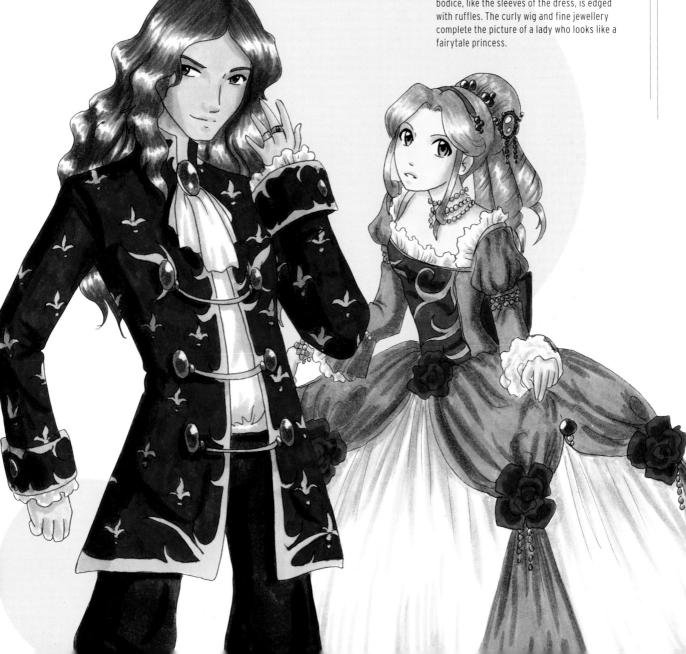

Folds in clothing

The fall of the folds in the clothes of your figure, whether shirts, trousers or skirts, gives the picture additional movement. It makes modern-day clothing look realistic and historical garments look romantic.

In order to draw the folds correctly, you must look very carefully at how your figure is standing or how it is moving, as the folds will emphasise the movement. Once you have done this, start to place the folds where the body moves, i.e. at the arm and leg joints and also around the join of the sleeves and at the neckline, the shoulder and waist.

You can locate these places on a mannequin, as they are where balls replace the joints. Folds also appear where shirts and trousers end, i.e. at the ankles and wrists. In short, folds appear anywhere where fabric is bunched together.

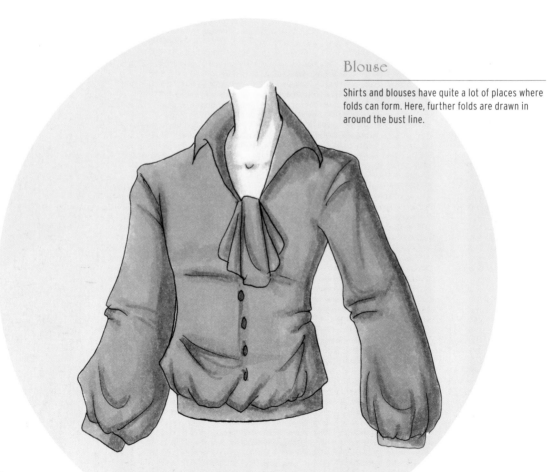

Blouse

Shirts and blouses have quite a lot of places where folds can form. Here, further folds are drawn in around the bust line.

Shirt sleeve

The cuff is actually smooth, but the broad sleeve billows out over it. Lengthways folds run parallel to the arm.

Trouser legs – bent

Pronounced folds form at the back of the knee when walking and sitting.

Trouser legs – straight

The trouser legs fall noticeably in a double fold over the shoes.

Skirt pleats

There are lots of types of folds or pleats in ladies' skirts. They range from primarily smooth skirts that will form folds only in certain situations, through to pleated skirts that consist completely of folds (as shown here). Skirt folds occur mainly at the waistband and at the ends. Very pronounced folds due to movement are only really seen on longer or wide skirts that are moved by the knee or the wind.

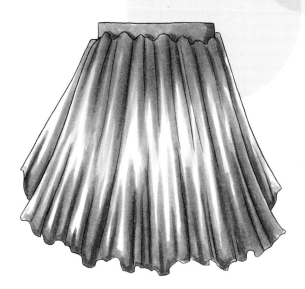

Jewellery

Fantasy figures in particular wear a lot of jewellery or adornments on their clothes and in their hair. These can take the form of flowers, stylised fruits and colourful ribbons or beautifully decorated chains or brooches with huge stones.

Do not hold back on the amount of jewellery and other accessories in the case of historical, legendary or celestial women. Even their clothes can be richly decorated.

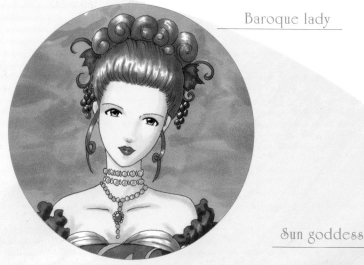

Baroque lady

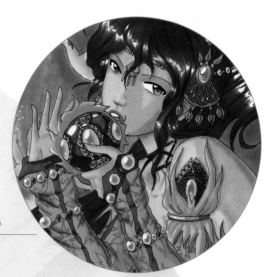

Sun goddess

Chain

You can use circles, ovals, squares or rectangles for the shapes of precious stones on chains. These pieces are joined together in various ways and decorated so that they match the character.

Historical characters, in particular, wear jewellery richly studded with precious stones.
Elves and fairies often wear jewellery bearing motifs from nature, such as flowers and leaves.

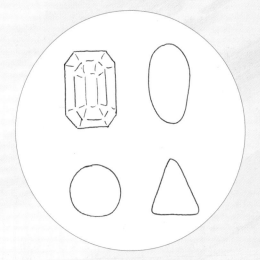

Flowers and blossom

In manga art, flowers are the most commonly used elements for backgrounds. They are also used as decorations for hair and clothes. Virtually every flower has a symbolic meaning too; for example, a red rose stands for love.

The closer a flower or blossom in the picture is to the observer, the larger it is and the more it can be painted in detail. Here are examples of gloxinia, a sprig of cherry blossom and a rose. The exact Copic® colour codes are given. Do not forget always to build up the colour from light to dark.

Whereas depicting the side view of a rose is good in the foreground of a picture or in the hand of a bishie (see page 60), the view from above is better for decorative use.

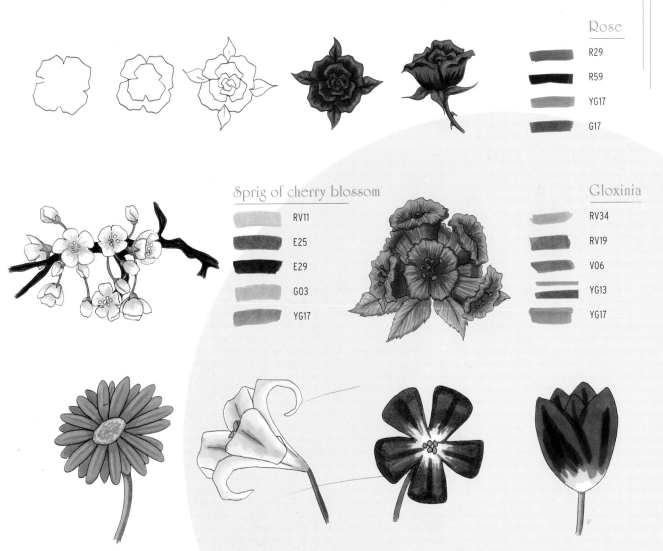

Rose

R29
R59
YG17
G17

Sprig of cherry blossom

RV11
E25
E29
G03
YG17

Gloxinia

RV34
RV19
V06
YG13
YG17

These flowers are really easy to portray. They are ideal as decorations. They can also be used to form a border, similar to that in the picture of the strawberry girl (see page 64).

Fantasy and magic

Shojo fantasy figures are an artist's delight, as you can really go wild with the colours and shapes of the figures. Elves, fairies and mermaids are very popular, as well as other fantasy creatures from mythology and the world of magical legends, fables and fairytales. Here you will find a small collection of typical fantasy creatures.

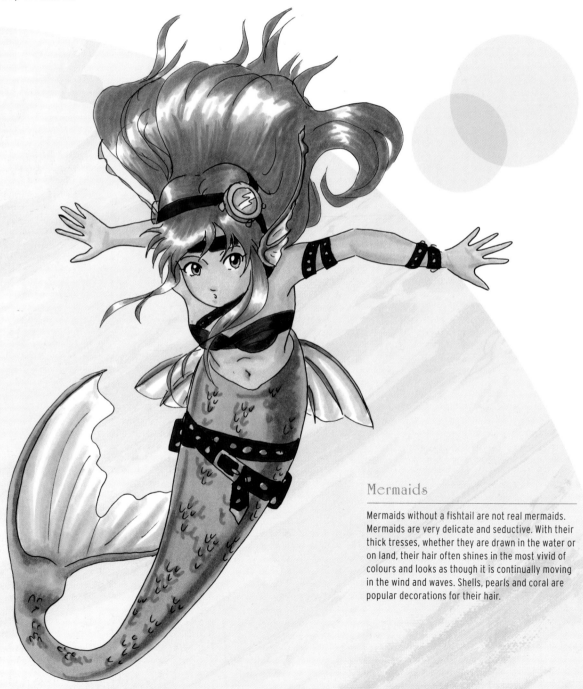

Mermaids

Mermaids without a fishtail are not real mermaids. Mermaids are very delicate and seductive. With their thick tresses, whether they are drawn in the water or on land, their hair often shines in the most vivid of colours and looks as though it is continually moving in the wind and waves. Shells, pearls and coral are popular decorations for their hair.

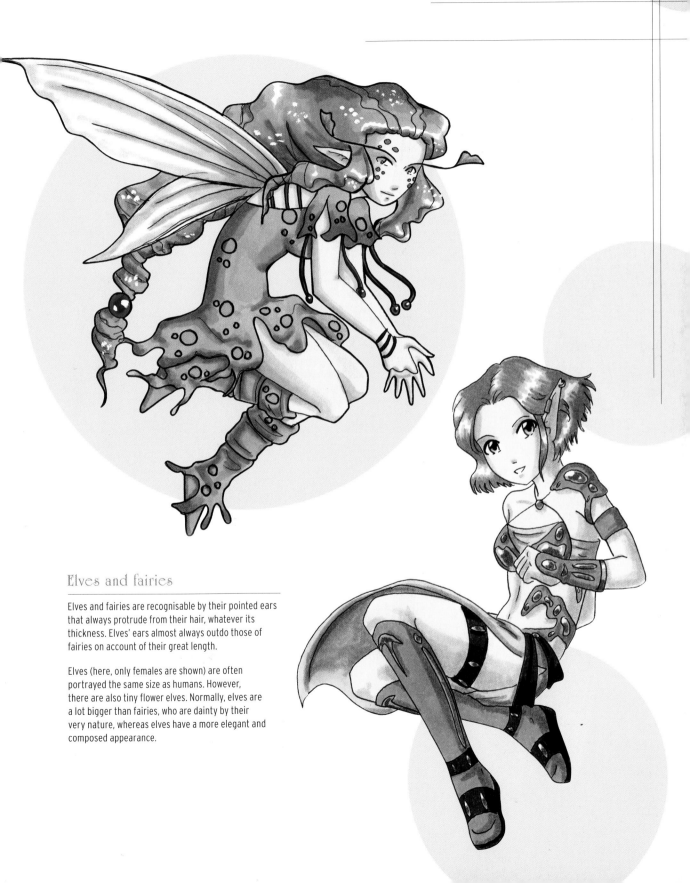

Elves and fairies

Elves and fairies are recognisable by their pointed ears
that always protrude from their hair, whatever its
thickness. Elves' ears almost always outdo those of
fairies on account of their great length.

Elves (here, only females are shown) are often
portrayed the same size as humans. However,
there are also tiny flower elves. Normally, elves are
a lot bigger than fairies, who are dainty by their
very nature, whereas elves have a more elegant and
composed appearance.

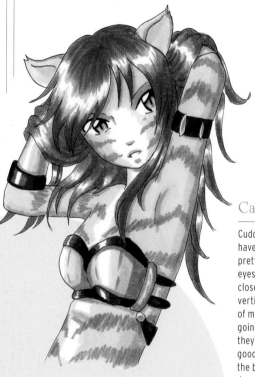

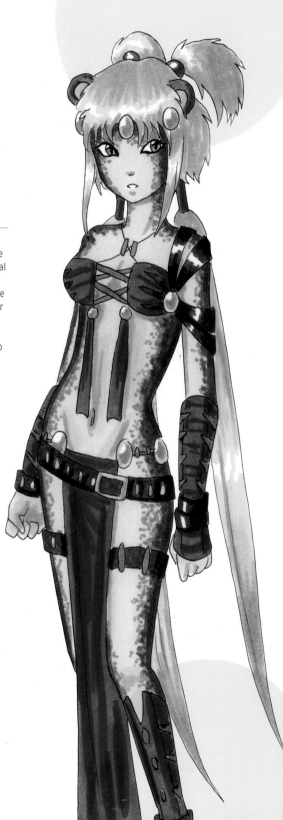

Cat people

Cuddly cats and savage cat people have one thing in common: they have prettily curved cats' ears and unusual eyes. If you look at the eyes of a cat closely in daylight, you will notice the vertical pupils. This gives them an air of mystery. You never know what is going on in their heads and whether they are well behaved or are up to no good. The type of fur is indicated on the body by darker dots or stripes, depending on the kind of cat.

Vampire-demon

As anything is possible with fantasy figures, you can have this interesting combination: a vampire-demon with a big head and a tiny body. With the big eyes looking at you so sweetly, you might perhaps overlook the little blood-sucking fangs in its mouth. The light is falling here from the top left, as a narrow shadow has been drawn on the right and lower sides to increase the three-dimensional effect of the figure.

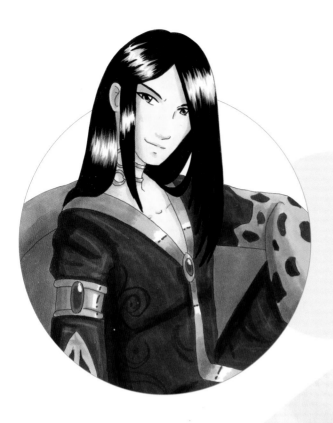

Chapter 8

Bishies

what are they?

Bishies (from 'bishounen' or 'bishonen' = attractive young man) are elegant, very attractive and often mysterious young men; you never really know whether they are noble or rogues. They are worshipped by young women, but other young men usually keep their distance from them (although many would secretly like to be like them). Bishies are almost always tall and thin and often have a willowy appearance. The narrow nose makes their face appear even more slender.

The bishie in the step-by-step depiction on page 60 has an elegant, yet unfathomable and seductive appearance. The turquoise of his hair indicates his noble descent.

The term bishie does not just stand for a particular figure, but for a manga style. Bishies can, for example, also be mythical animals or half-animal/half-human. What matters is their attractiveness and elegance.

Bishies from the front

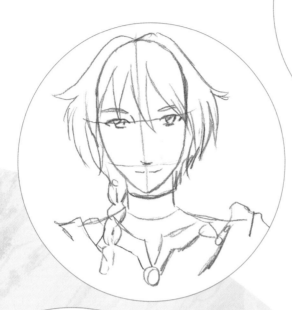

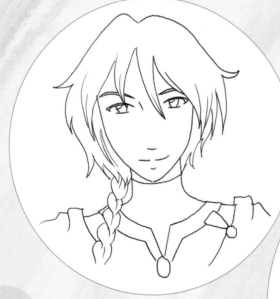

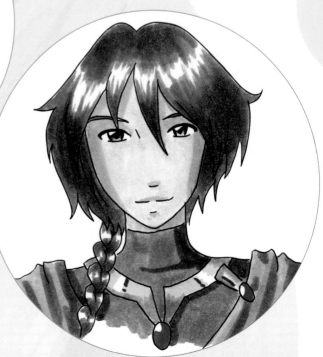

Bishies from the front

The most striking difference between a bishie and other males is the shape of the head and eyes. The face of a bishie is longer than that of other male figures. The chin is more pointed, which gives him a more adult appearance. The eyes are narrower and there is something impenetrable and mysterious in his look. The whole demeanour is one of elegance.

Bishies in profile

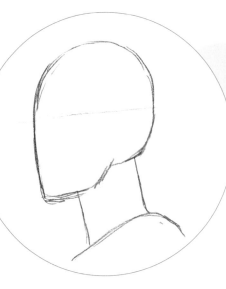

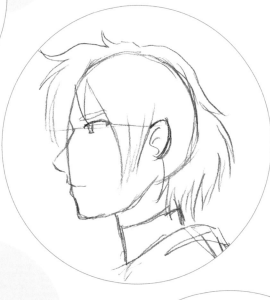

Bishies in profile

In profile, it is clear how angular the face is in comparison with the heads of other boys. The nose is longer and the chin more pronounced. The neck is stronger too.

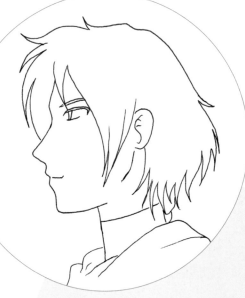

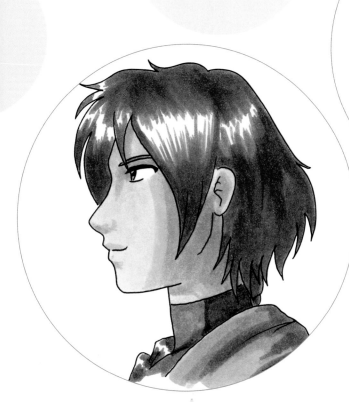

Bishies in semi-profile

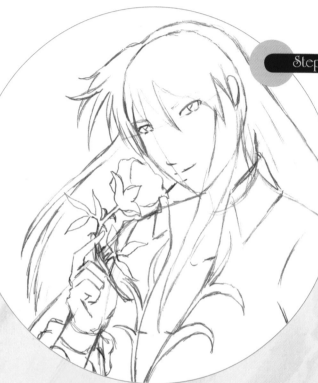

Step 1

First, decide on the position and posture of the figure in the picture. The face is sketched in semi-profile. To do this, draw in the corresponding vertical and horizontal guidelines, making the side of the face that is turned towards the observer larger. Only then will the mouth, nose and eyes be in the right place. The long hair has an elegant sweep. The hand is drawn in a particular pose. You can work out the position of the thumb and index finger when holding the rose by looking at your own hand.

Step 2

When inking, remove all the unnecessary strokes, as before, or transfer the sketch to transparent layout or marker paper. Here, only very thin outlines have been drawn.

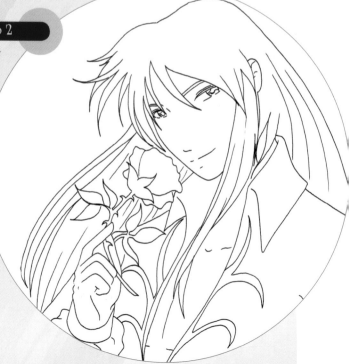

Tip

If you are uncertain how to draw a particular posture, ask your brothers and sisters, friends or parents to be models. You can ask them to stand/sit in the desired pose and then draw them.

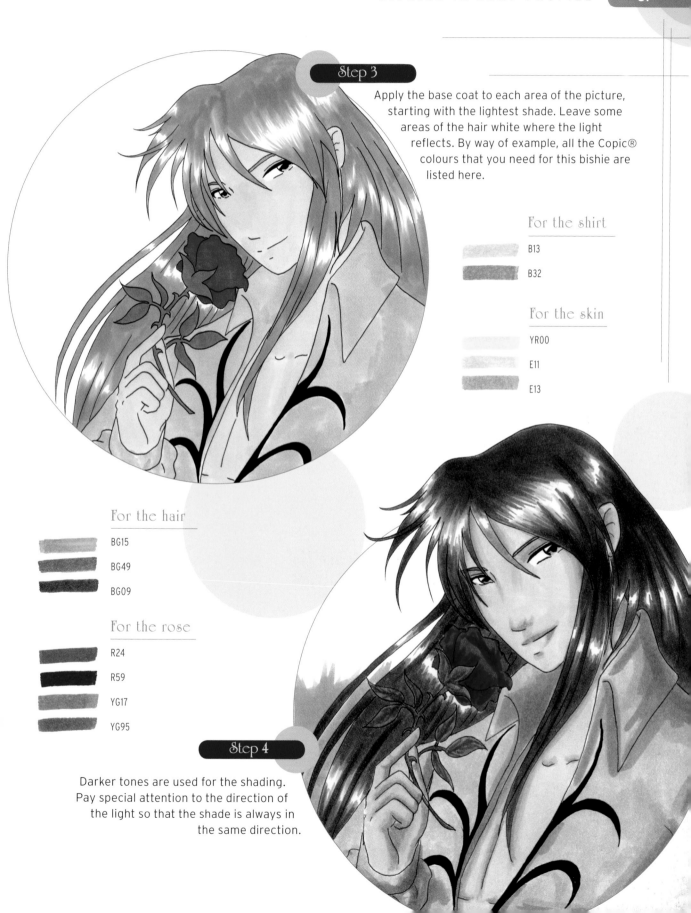

Step 3

Apply the base coat to each area of the picture, starting with the lightest shade. Leave some areas of the hair white where the light reflects. By way of example, all the Copic® colours that you need for this bishie are listed here.

For the shirt

B13

B32

For the skin

YR00

E11

E13

For the hair

BG15

BG49

BG09

For the rose

R24

R59

YG17

YG95

Step 4

Darker tones are used for the shading. Pay special attention to the direction of the light so that the shade is always in the same direction.

Types of bishie

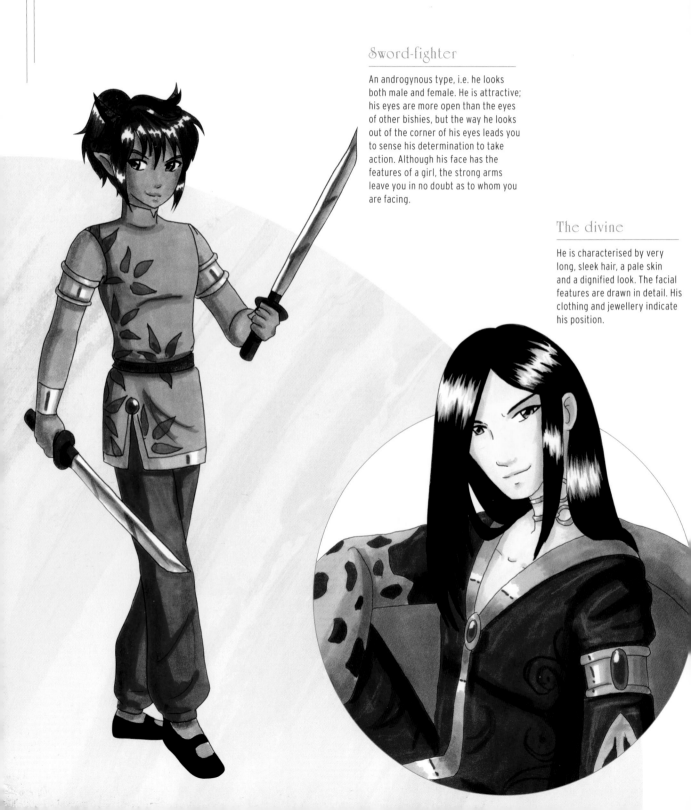

Sword-fighter

An androgynous type, i.e. he looks both male and female. He is attractive; his eyes are more open than the eyes of other bishies, but the way he looks out of the corner of his eyes leads you to sense his determination to take action. Although his face has the features of a girl, the strong arms leave you in no doubt as to whom you are facing.

The divine

He is characterised by very long, sleek hair, a pale skin and a dignified look. The facial features are drawn in detail. His clothing and jewellery indicate his position.

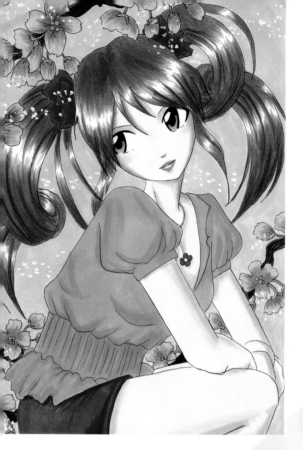

Chapter 9

Gallery
of shojos and bishies

The strawberry girl

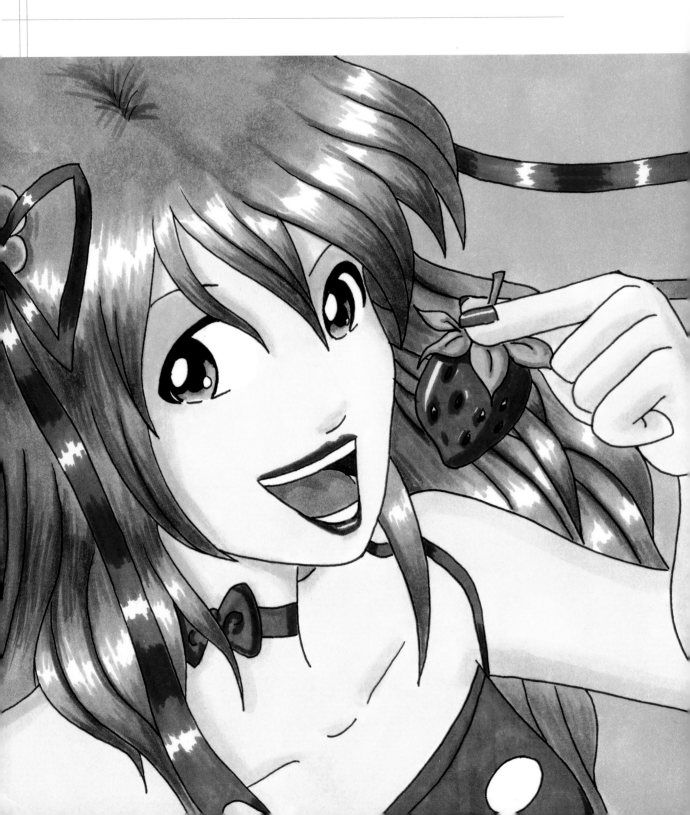

APPEARANCE: The girl's open mouth and radiant eyes make you want to eat sweet strawberries yourself.

CHARACTER: A happy girl in a happy mood. She just loves strawberries.

DRAWING: A striking positioning of the figure at the outer left edge of the picture. The strawberry border in a golden section against a pastel pink background completes the picture, both in terms of colour and composition.

Eat strawberries, they make you happy! This is the thought that jumps to mind when looking at the sweet strawberry girl about to take a bite of the fruit. It could easily be an advert for them.

By looking down on the girl from above at a slight angle, the picture is made more interesting. There is a lot of movement, thanks to the position of her arm and the flowing ribbons and hair.

All these pictorial elements stand out against a tranquil background in pastel pink (which is the lightest shade), on which there is a decorative border of juicy red strawberries. The red R29 from the Copic® range for the dress and lips, and for the neck and hair ribbons, is applied last, as otherwise it would mix with the skin colours E00, YR00 and E11, also by Copic®.

The picture has depth due to the shading of the strawberries, the hair ribbons and the lips using R59 Cardinal.

Catsy – the prickly feline amazonian

APPEARANCE: The expression in the eyes and the slightly open mouth, as well as the headband and the jewellery, are what strike you first of all. The 'clawed' hand helps give this picture its name.

CHARACTER: This kitten is not one to be played with. She is prickly, aggressive and on the attack.

DRAWING TECHNIQUE: A dynamic composition due to the position of the head and hand, the wild hair and the leaves swirling around in just a few, harmonising colours.

The cat is a popular creature, even if it can be prickly. You see cats everywhere, in the neighbour's garden, in advertising or in the widely acclaimed musical!

Catsy is an aggressive cat, on the attack. Her insignia are the finely engraved metal arm and neck bands, along with the headband. They serve both as protection and as a symbol of strength, emphasising the hostile and ferocious nature of this feline amazon.

The colour of the yellow cats' eyes stand out and they look out at you boldly through the wild strands of hair. You need to be careful of her claws, even if they look a little less dangerous here with their fashionable manicure.

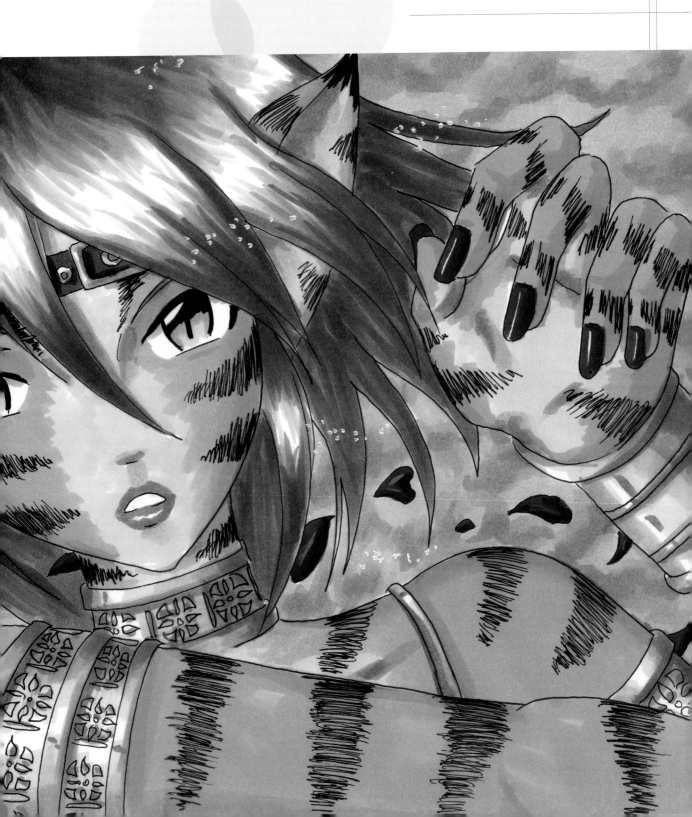

The wolf girl

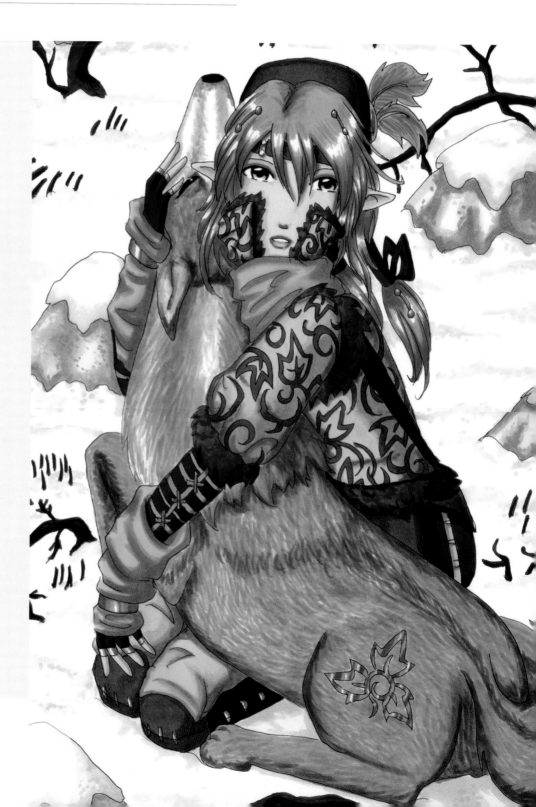

APPEARANCE: An elf, wearing clothing in earthy and natural shades and with a penetrating gaze fixed on the observer.

CHARACTER: The wolf is held and embraced in a protective, loving gesture. The elf's gaze is fixed upon a potential pursuer in the distance.

DRAWING: A stark contrast between the winter landscape and the warm earthy and natural colours of the clothing and hair. The wolf's fur is drawn using fine hatched strokes in various shades of grey that follow the shape of the body and give it a three-dimensional appearance.

Who will play with me?

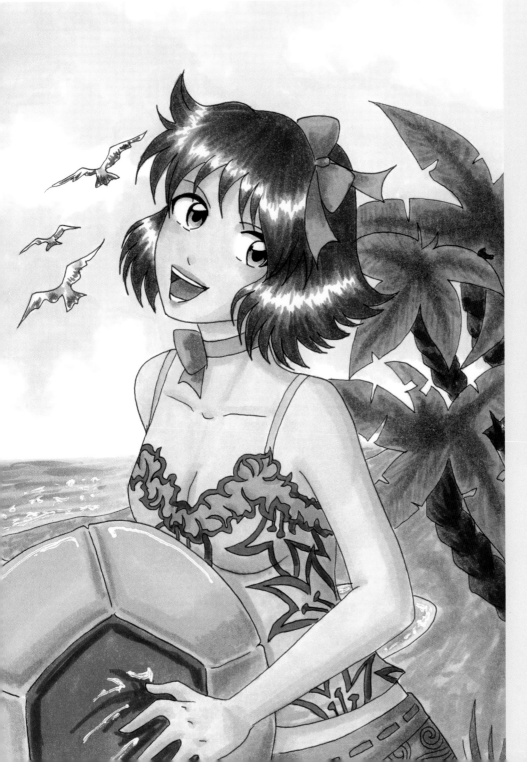

APPEARANCE: Childlike, happy, carefree and inviting play. The environment is a dream holiday destination.

CHARACTER: The appearance and character of the figure go hand in hand here.

DRAWING: This girl is only really suited to this kind of environment: happy colours, a blue sky, blue sea and a golden beach.

In the rose garden

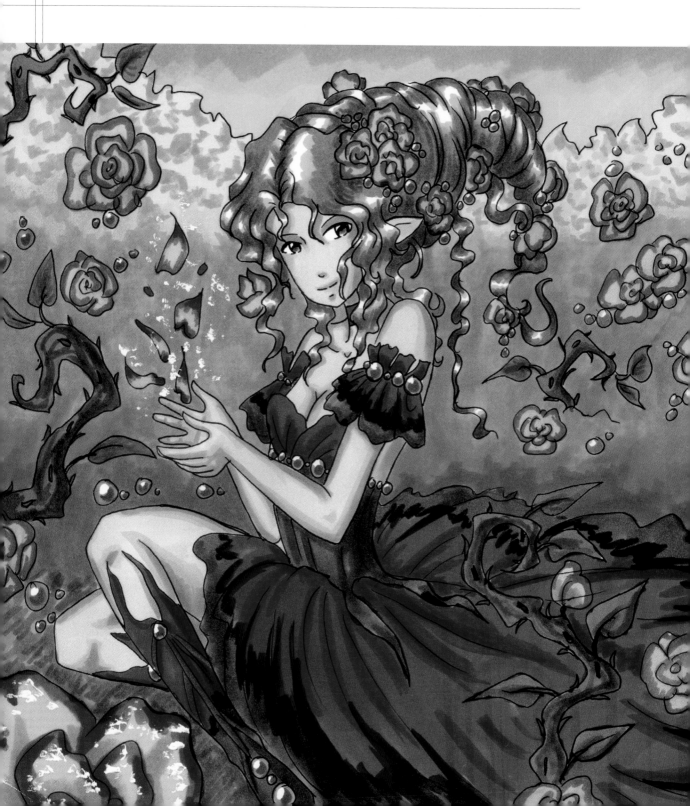

APPEARANCE: A real queen of the roses – a vision that has virtually evolved organically along with the surrounding nature.

CHARACTER: Self-confident in her beauty and in her role as queen of the roses. Her gaze invites you to visit her in her kingdom.

DRAWING: Baroque hairstyle and clothing, in an intense red and green colour scheme. A dynamic picture due to the swirling roses and the billowing skirt.

This is an attractive elf, who sweeps through the world of roses untouched. This 'sweeping' is reflected in the picture. Flowers and thorny hedgerows swirl around one another and the skirt billows along the fluttering train. Her radiance makes the green and red more intense. The unusual motif with the long train flouts the usual rule of never putting a person to one side against the edge of the picture.

The colours all blend well, although the elf's costume with its decorative elements pushes the figure into the foreground.

The secret stranger

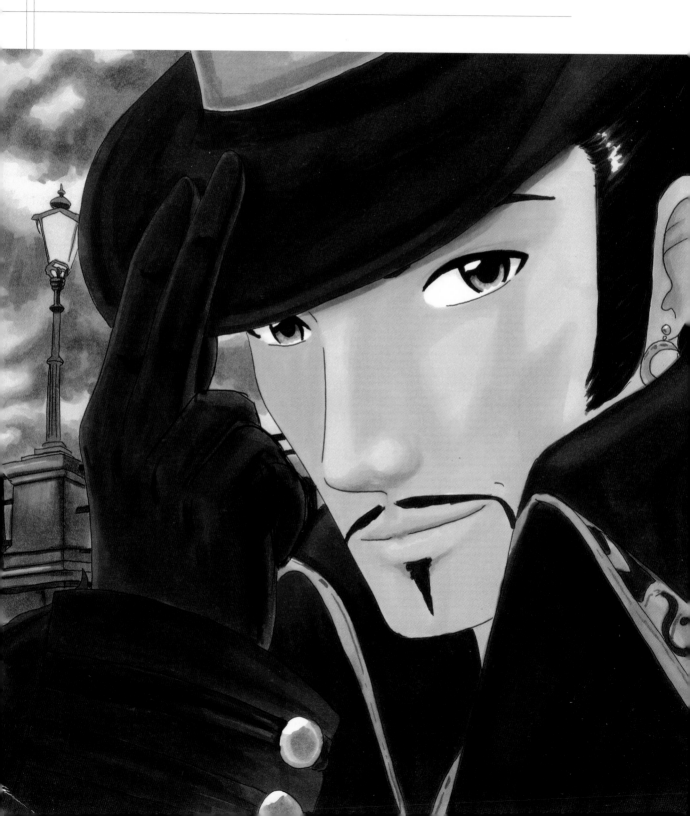

APPEARANCE: Elegant, with a well-groomed appearance and stylish clothes.

CHARACTER: Elegant like his appearance, seductive yet difficult to categorise.

DRAWING: Distinctive sombre colours and the details of the environment match the appearance and character of the figure perfectly.

Mysterious, curious, yet also a little distant? In Paris, London or St Petersburg in the nineteenth century? Who is he really, this mysterious man? Where is he? Does he really live in that era?

A successfully composed picture with striking details: although it is just a small extract, it is emotive and dramatic, with the two gloved fingers touching the brim of the hat by way of a greeting, and with the narrow moustache and goatee and the hint of an earring.

The colours of the facial area are impressive, due to the fine light-to-dark shading – a painting technique that requires a lot of practice. Apart from that, only two other significant colours are used in the picture: the reddish shade on the clothing and the grey shade of the bricks of the bridge and the atmospherically dramatic night sky.

The elf with the lily

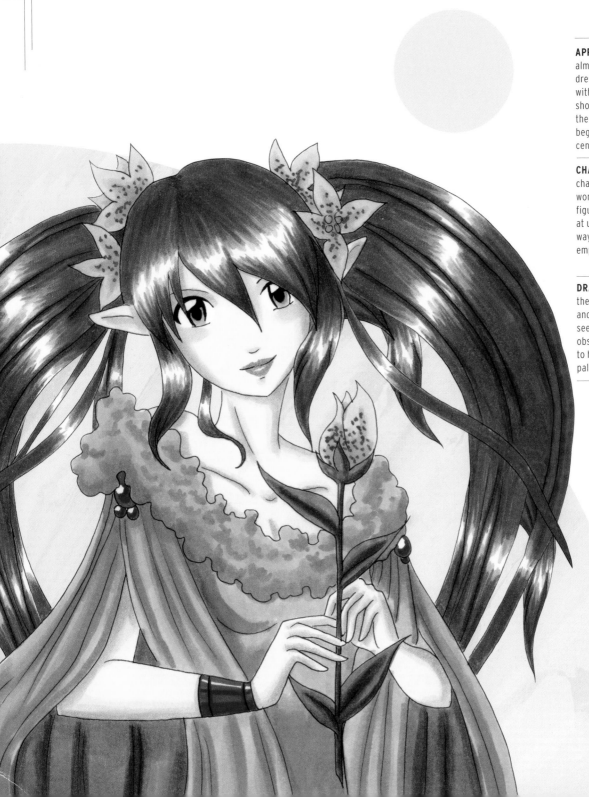

APPEARANCE: A dainty, almost fragile creature, dressed in a historic gown with a ruffle around the shoulders, as in antiquity or the age of Empire (France, beginning of the nineteenth century).

CHARACTER: In a word: charming. This pleasant word describes well this figure of a girl who is gazing at us lovingly. The graceful way she is holding the flower emphasises this impression.

DRAWING: Although the green of her dress and her cute pigtails seem to dominate, the observer's gaze is drawn to her delicate and rather pale face.

The futuristic girl

APPEARANCE: Risqué, futuristic outfit. Fantasy accessories.

CHARACTER: A strong character from the world of science fiction: she looks fantastic, is bright and assertive, and definitely a little cheeky as well.

DRAWING: A three-dimensional appearance thanks to the placing of the figure in front of the blue stripe in the background.

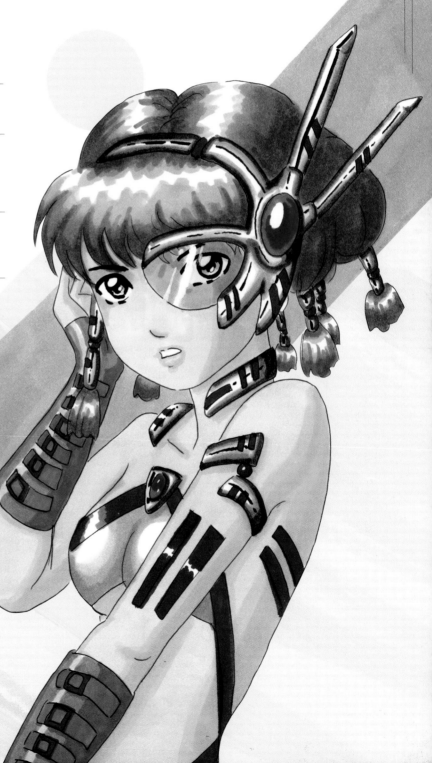

The blue flower elf

APPEARANCE: Winged, with blue hair and surrounded by bluebells.

CHARACTER: Somewhat unfathomable, oscillating between good and evil.

DRAWING: Dynamic picture achieved by floating feathers. The colour blue dominates. Balanced use of space.

A magnificent blue flower elf. She is recognisable as an elf from her pointed ears that stick out through her hair on either side of her head. Flower elves are actually good elves, but the frame of mysterious bluebells and the black background mean that you are not quite sure whether this beauty inside her forms a fine line between good and evil. Her gaze, which is slightly questioning and directed towards the observer, radiates calm. While not unpleasant, the fact that this figure is coming out of the darkness makes her actual frame of mind difficult to read.

There is a lot of movement in the picture around the central figure. This is produced both by the outspread wings and by the swirling feathers.

The colours all blend well, but the elf costume with its jewels makes the figure the focal point.

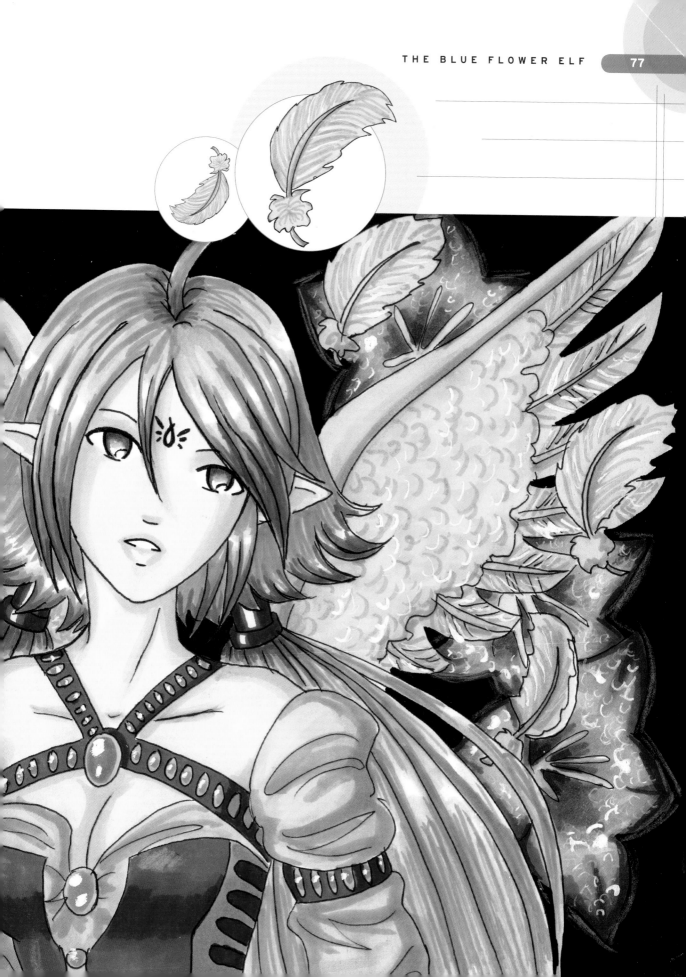

The storm queen
(on page 63)

In Germanic mythology, the storm queen is the whirlwind produced by the female spirits of nature. It is a name also frequently given by seamen to a ship. In art and literature, the name has many connotations.

This shojo is a real storm queen too. Her fine face is given an impetuous look by her hair swirling wildly in the wind. Reflected lights in the red hair intensify its wavy movements. Green leaves fluttering past add contrast to the scene.

A classic creative principle is used here to good effect: if a portrait is produced in profile or in semi-profile in landscape format, the head should not be in the middle of the picture but always to one side, as here. The gaze must always then be in the direction of the larger area of space, as otherwise the person in the portrait would be looking at the edge of the picture, such as at the wall. This rule also applies to a full-body portrait on a smaller scale, and it applies to photographs too.

The cherry blossom girl
(on page 63)

Dreamy, romantic and very sweet – this girl is sitting expectantly under the sprigs of blossom.

Strongly contrasting colours are used against a receding, pastel blue background. Yet there is also a relationship between the red colour of her shorts, her pendant and the flowers decorating the roots of her pretty curls. The way the figure fills the picture with her pose and her full hairstyle is striking.

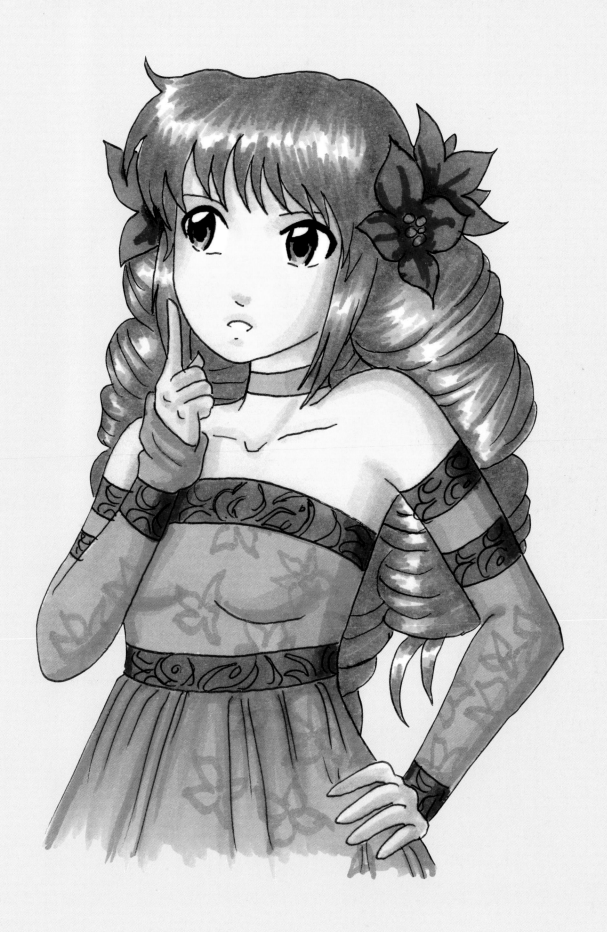

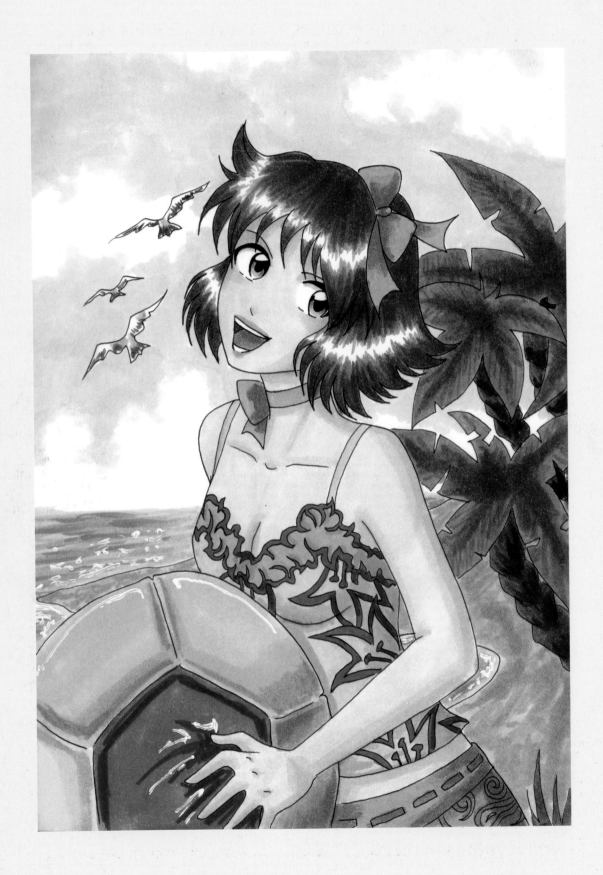